LEGENDARY L

OF

PELHAM

NEW HAMPSHIRE

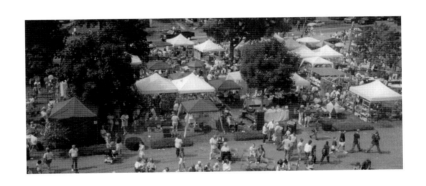

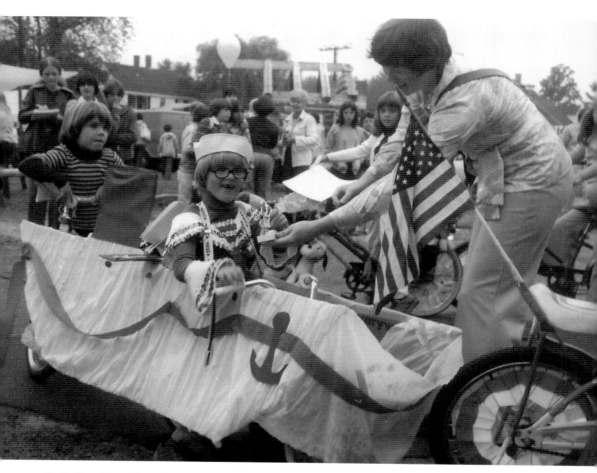

Doll Carriage Parade
A traditional part of the Old Home Day Celebration is the Doll Carriage Parade. Children are encouraged to decorate their wagons, carriages, or bicycles and parade across the main stage for prizes. (Courtesy of First Congregational Church.)

Page 1: Old Home Day Celebration
For over 100 years, residents of Pelham have enjoyed the Old Home Day Celebration in the middle of town. The event features shows, music, raffles of all kinds, local organizations, vendors, food, and fun. Legend has it that Old Home Day has never been rained out. (Courtesy of First Congregational Church.)

LEGENDARY LOCALS

— OF —

PELHAM

NEW HAMPSHIRE

*Enjoy the legends
y Pelham!
Diane Chubb*

DIANE CHUBB

LEGENDARY
LOCALS

Copyright © 2014 by Diane Chubb
ISBN 978-1-4671-0075-5

Legendary Locals is an imprint of Arcadia Publishing
Charleston, South Carolina

Printed in the United States of America

Library of Congress Control Number: 2012955670

For all general information, please contact Arcadia Publishing:
Telephone 843-853-2070
Fax 843-853-0044
E-mail sales@arcadiapublishing.com
For customer service and orders:
Toll-Free 1-888-313-2665

Visit us on the Internet at www.arcadiapublishing.com

Dedication

This book is dedicated to Lt. Col. John S. Hernandez and Joan Hernandez, my parents, and Lt. Gen. Melvin F. Chubb and Judith Chubb, my husband's parents. From both families, the sacrifices that one makes for a better community, on a national and local level, are clear. A great community requires time and effort. In Pelham, I see this dedication and passion in so many residents who just want the town to be a great place to live. I am proud to call Pelham my home.

On the Front Cover: Clockwise from top left:
Victoria Greenwood (Courtesy of Jim Greenwood; see page 118), Herb & Martha Currier (Courtesy of First Congregational Church; see page 23), Pelham Softball (Author's collection, see page 124), Doll Carriage Parade (Courtesy of First Congregational Church; see page 2), Pelham Starlighters Drum & Bugle Corps (Courtesy of Eleanor Burton; see page 122), Shaun Doherty (Courtesy of Shaun Doherty; see page 54), Victor Spaulding (Courtesy of First Congregational Church; see page 70), Eleanor Burton (Courtesy of Eleanor Burton; see page 27), Pelham Ice Garden (Courtesy of Jim Greenwood; see page 46).

On the Back Cover: From left to right
E.G. Sherburne School (Courtesy of First Congregational Church; see page 125), Old Home Day Celebration (First Congregational Church; see page 1).

CONTENTS

ACKNOWLEDGMENTS

Thank you to the wonderful families and friends in Pelham who opened up their personal collections to me. I spent many incredible hours talking to some amazing people in town, people who think nothing of the time and energy they have spent in service to Pelham and seek no credit for their accomplishments.

I would especially like to thank Eleanor Burton, Jane Provencal, Cheryl and Glen Hirsch, Linda Doherty, Cathy Pinette, Jim Greenwood, Jackie Blanchette and Bill Scanzani for their extra efforts on my behalf, and Phil Currier for his wonderful photograph collection.

Sue Hoadley has been my personal research assistant, secretary, and editor. A former paralegal, she understands the crazy work habits of an attorney. I could not have done this without you!

And finally, thank you to my family. My husband, Brandon, had to put up with my late nights "authoring," and my children, Rachel and Jason, patiently attended many meetings with me.

Unless otherwise indicated, photographs are from the author's personal collection.

INTRODUCTION

Named for Thomas Pelham Holles, Duke of New Castle, England, Pelham was incorporated as a town on July 5, 1746. The name was chosen by the governor of the province of New Hampshire, Benning Wentworth, in honor of the duke who had appointed him. The people of Pelham did not object, as they were pleased to finally have their petition to be a town granted.

For years, the land comprising Pelham was in some dispute. Originally part of the Massachusetts Bay Colony, pieces of Pelham were known as Tyngsborough, Dunstable, and Nottingham. The original Dunstable was 200 square miles, consisting of land on the east of the Merrimack River—including one-third of Pelham, part of Tyngsborough and almost all of Hudson.

According to local history, the first settler was John Butler of Woburn, Massachusetts. In 1721, Jonathan Tyng conveyed to Butler 450 acres of land in Dunstable adjoining the Dracut line, and another 150 acres next to the first lot. The border between Dunstable and Dracut ran from a pine tree near Beaver Brook to Long Pond, crossing the "mammoth road."

Butler built his home on the east side of Mammoth Road, constructed of pine logs with a ditch around it and a drawbridge, to protect his family from Indian attack. Butler was named deacon in Pelham and Hudson. He and his wife, Elizabeth, went on to have 10 children, all of whom married and settled nearby. Their sons chose to stay in Pelham, with Samuel at a farm at the foot of Jeremy Hill, Joseph to the northwest corner of Pelham with the nearby mills, and Jacob on the homestead and Gumpus Pond mills.

In the early 1900s, Pelham was primarily an agricultural town. Large family farms provided dairy products and fresh produce to supply the neighboring mill cities.

The wide-open spaces, four large, clear ponds, and two long, fish-filled brooks brought city dwellers to Pelham to escape the summer heat. Visitors easily traveled to Pelham, Canobie Lake, and other destinations conveniently located along the trolley line.

Large homes were converted to boardinghouses, and people built summer cottages on Long Pond, Gumpas Pond, and Little Island Pond. In 1906, the Harris family opened the Grand View House on White's Pond.

Eventually, better transportation made it possible for people to travel further for vacation. New highways bypassed Pelham, and the town's reputation as a summer resort ended.

Nevertheless, charitable organizations found Pelham the ideal summer recreation spot. The Greater Lowell Girl Scout Council bought more than 200 acres of the old Frye Gage Farm on Little Island Pond, which now operates as Camp Runnels.

In the 1940s, the Lowell YMCA purchased 56 acres along Long Pond to create Camp Alexander. When the camp closed, the town purchased the land. Three-war veteran John Hargreaves advocated the camp be renamed Veterans' Memorial Park.

Nashua Girl Scouts bought 80 acres of the former Sherburne Homestead on the shore of Long Pond in the 1950s and established Camp Kiwanis. The camp was later sold to a private developer.

In a new community, the first building usually constructed was a combination church and meetinghouse. The first settlers voted to build a meetinghouse in 1746, but nothing was done. In 1748, they voted to purchase the Nottingham West Meeting House, take it down and move it to Pelham. Before it could be moved, the people of Hudson stripped the building of its benches, floors, windows and casings. Only the frame remained, which was erected on two acres of land near the site of current First Congregational Church.

This meetinghouse was used until 1785, when a new one was constructed on the common, known as the Great Meeting House. It was located on the west side of the common, near the former fire station.

The Great Meeting House was used by the First Congregational Society until 1842. After several unsuccessful attempts to purchase the building from the town, they decided to find land for their church.

On land donated by Gen. Samuel Richardson, the First Congregational Church was built and dedicated on December 28, 1842. The pipe organ was installed in 1859, and the clock tower in 1904–1905. Rev. Augustus Berry was the pastor of the First Congregational Church from October 1861 until his death in October 1899.

The town took over the meetinghouse, using it as the town hall and renting the space for community events. In 1893, the public library was established in a corner of the town hall as well.

Eventually, the building needed major repairs. In 1904, residents finally approved the funds for the project. Two years later, the town hall burned down and all was lost.

Town meetings were moved to Pilgrim Hall, which was built in 1901 by the General Stark Colony No. 30 of the United Order of Pilgrim Fathers, on land purchased from the Woodbury family. It took 10 years to pass a warrant article for a new town hall. In 1917, the town purchased Pilgrim Hall, which served as Pelham Town Hall until the new municipal center was constructed in 2003. The building now belongs to VFW John H. Hargreaves Memorial Post No. 10722.

Early on, a group of residents determined that the public library needed a separate building. Land was donated by Frank Woodbury next to the First Congregational Church for a library and memorial to Pelham's war veterans. The building was completed in 1896. Mary Hobbs, known to all as "Aunt Molly," was the first librarian.

Space was at a premium in the library. In 1975, the basement was renovated to create a children's room, staff workroom, and storage. When the new municipal center was constructed in 2003, it included an ADA-compliant library building. The former library now houses the Pelham Historical Society, and was listed on the Register of Historic Places in 2011.

Schooling was done mainly in private homes. In 1719, Colonial Law required that every town with 50 families have a schoolmaster and that towns with 100 families have a grammar school. In 1767, Pelham had just over 500 residents.

A committee was appointed in 1775 to establish schools in each geographic corner of town. Residents of each section would build and maintain them.

Each section was given a number (longtime Pelham residents still identify areas of town with these section names):

District 1: Pelham Center
District 2: Gumpas
District 3: North Pelham
District 4: Gage Hill
District 5: Currier Highlands

The district schools were one-room schoolhouses that went up to grade six. Junior high classes were held over Atwood's Store in Pelham Center.

In 1920, land was deeded to the school district, and a four-room school building near the Town Center was constructed for a junior high. Now part of the current town hall, the original building was white clapboard. The original beams and ceiling are still visible in the Planning Department office. Although more modern than the one-room schoolhouses, it lacked plumbing or electricity.

In 1950, an addition was constructed and the building renamed E.G. Sherburne School. Pelham Memorial School was built in 1965. But space remained an issue.

In 1971, another addition was built onto Sherburne School, with 12 more teaching stations, a teacher's room and an Instructional Materials Center. Grades 1-4 were at Sherburne and 5-8 at Memorial School.

Pelham paid for its high school students to attend classes in neighboring towns. With no transportation available from the school district, students took trolleys to attend school in either Lowell or Nashua, or received rides from friends. In later years, students were bused to Alvirne High School in Hudson.

In 1974, a cash-strapped Pelham constructed its own high school for grades 9-12. But space was still an issue and the Sherburne School required renovation. After many town meetings, voters finally approved construction of Pelham Elementary School, which opened in 2002. E.G. Sherburne School was transformed once again, this time into the municipal center.

Now Pelham had a new town hall, public library, police station and community space for theatrical stage performances, civic events and town-wide meetings for up to 400 people, all centered on the new Village Green.

Because of its proximity to Lowell and Nashua, Pelham was home for many who worked in the mills and factories. Railway companies built track for the trolleys alongside main roads and through open fields. The intersection of the tracks and stations made it possible to go just about anywhere. Cars were filled to capacity on weekdays, shuttling workers to jobs.

The railway companies constructed amusement parks to increase weekend usage of the lines. Canobie Lake Park, built on the shore of Canobie Lake in neighboring Salem, New Hampshire, was built in 1901 by the Hudson, Pelham & Salem Electric Railway Company. Residents of Pelham and other neighboring towns could board an open air trolley car in the summer for the short trip to the park.

The Massachusetts Northeast Street Railway's Salem Division consisted of four connected lines in communities along the New Hampshire and Massachusetts border—the Haverhill and Southern New Hampshire line, the Lawrence and Methuen line, the Lowell and Pelham Street Railway, and the Hudson, Pelham and Salem Electric Railway (HP&S). The lines were connected through two trolley car barns, one located in Salem and one in Pelham Center.

The HP&S streetcar line ran from Pelham to Nashua over 9.28 miles of track, traversing land owned by the Muldoon Family, through Hudson and over the Merrimack River to Nashua. Pelham Center was a gateway for residents of Hudson and Nashua.

A horrific trolley crash in Pelham in September 1903 killed six. It was the beginning of the end for railcar service in southern New Hampshire. The HP&S line never recovered financially. The arrival of the popular Ford automobile provided an alternate method of transportation. HP&S was forced into receivership in December 1904, and its parent company, New Hampshire Traction Co., went bankrupt in 1905.

In 1923, service from Pelham to Lowell ended. The car house in Pelham was demolished during World War II, and the "trolley barn" was purchased by St. Patrick Church for a recreation center. However, it fell into disrepair and was finally leveled in September 2008.

Over the past 100 years, Pelham has seen tremendous growth. Voters have not always supported change, and it often took many years and several town meetings to build the infrastructure in place today.

But wherever there was a real need, civic-minded residents raised their hands to help. They built sports fields, stocked food pantries, supported schools, and served on boards and committees. People donated time, land, money, energy and expertise to create the community they wanted to live in.

CHAPTER ONE

In Service to
Our Country

Pelham has sent its sons and daughters to war since before the United States was officially a country. Soldiers served in the French and Indian Wars and the American Revolution. Later, townspeople would fight in the Civil War, the great World Wars, Korea, Vietnam, and Iraq. These people are honored with their names on the walls of the former Pelham Public Library, now the Pelham Historical Society building.

Those who were fortunate enough to return to Pelham went on to contribute to the growth of the community. Not all of the soldiers received the opportunity to return to civilian life. Pelham honors its fallen heroes, remembering their sacrifices for the greater good.

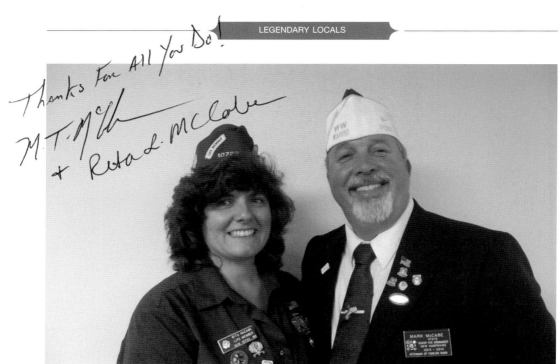

Thanks For All You Do!
M.T. Mc.....
+ Rita d. McCabe

Mark and Rita McCabe

The former Pilgrim Hall houses Pelham's Veterans of Foreign Wars John H. Hargreaves Memorial Post No. 10722.

From 2010 to 2014, Mark McCabe was post commander, with his wife, Rita, serving as Ladies' Auxiliary Chair. The VFW regularly partners with Moore Mart, a nonprofit group that provides care packages for soldiers serving in other countries. In recent years, the post has increased its visibility in the community and won national recognition.

A regular face around Pelham, Mark always has a smile as he encourages participation in civic activities. He is very vocal about support for veterans.

In 2013, Rita started a Junior Girls division. The girls work alongside the Ladies, providing assistance at events, organizing items for local veterans' hospitals, and raising funds for the National Children's Home.

On June 15, 2014, Mark was sworn in as New Hampshire state commander for the VFW.

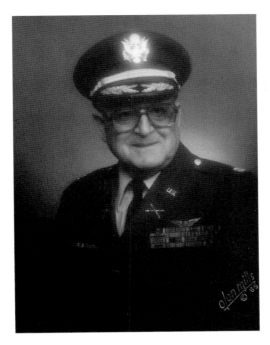

John Henry Hargreaves

His license plate read "3 WARS," which said it all. Born in Methuen, Massachusetts, in December 1919, John Hargreaves would serve in three wars—World War II, Korea, and Vietnam.

He travelled the world, seeing the death and destruction of war firsthand. During World War II, he served in Greenland, protecting local airbases from German attack. After a short leave, Hargreaves was in Hiroshima, Japan, as an eyewitness to the devastation left by the atomic bomb.

In 1962, he served as Field Artillery Advisor to the Third Corps of the Iranian Imperial Army in Iran. His last assignment was Vietnam during the 1968 Tet Offensive. Hargreaves retired in 1971 as command sergeant major, the highest rank achievable for an enlisted soldier.

Hargreaves moved to Pelham in 1971, becoming very active in veterans' affairs. He reinstated the Veterans of Foreign Wars post in town, and served as post commander in 1985. He was also a 50-year lifetime member of American Legion Post 100 in Pelham.

Hargreaves spoke at many Memorial Day and Veterans' Day observations, schools and youth organizations. He was the first to answer any questions about veterans' affairs.

Not one to take "no" for an answer, Hargreaves could be very persuasive. "He would talk until he got you to agree with him," says his wife, Anne.

After Pelham acquired the Lowell YMCA Camp Alexander, Hargreaves was the driving force in renaming it Pelham Veterans' Memorial Park and constructing the monument.

Hargreaves loved to educate people about the proper care and display of the American flag. He paid attention to the flags on public buildings, making sure they were flown correctly. If necessary, he purchased replacements.

After the September 11 tragedy, Hargreaves acquired a special "First Responders" flag, donating it to the Pelham Police and Fire Departments.

His younger brother, also active in veterans' affairs, had started an "Avenue of the Flags" in Methuen. Deciding that Pelham needed one too, Hargreaves contacted the utility companies, seeking permission to mount the flags on their poles. He purchased the flags, and beginning on Memorial Day 2000, Pelham's Avenue of Flags was created along Old Bridge Street.

Following his death in 2004, Pelham's VFW post was renamed the John H. Hargreaves Memorial Post No. 10722 in his honor. (Courtesy of Anne Hargreaves.)

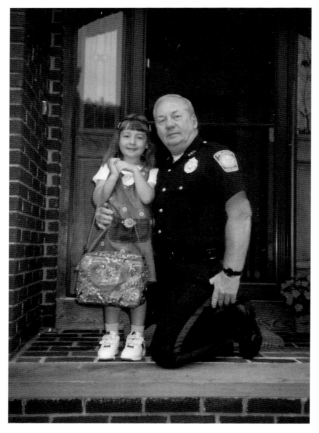

Dennis Patrick Lyons

If it was meatball sub day at school, chances were good that Officer Dennis Lyons was there having lunch.

For more than 25 years, Lyons served Pelham as a police officer. He joined the department in 1978 and became the town's school resource officer. Pelham's first community policing officer, he was also an accident reconstruction specialist.

Lyons was born in Castine, Maine, in 1948 and graduated from Lowell High School in 1966. A Navy veteran, Lyons served as a hospital corpsman with the Marines during the Vietnam War. He later attended the police academy at Pease Air Force Base in Portsmouth, graduating in May 1979. He received numerous commendations during his career, including the VFW's Pelham Police Officer of the Year.

Considered one of the last true "community" officers, Lyons was known for his ability to work with the people in town. Lyons believed that it was easier to get a kid to cooperate by saying he was going to call their parents, rather than threatening arrest. To this day, parents and kids still remember his considerate treatment.

Lyons and his wife, Cynthia (Daniels), enjoyed 27 years of marriage. His daughter, Meghan, was the light of his life. They would be seen together at Cousins enjoying English muffins, running errands, or in the town parades.

To raise funds for the Pelham Police Relief Association, Lyons organized softball games with sports celebrities. He created the annual golf tournament, which now bears his name.

Unfortunately, in March 2004 Lyons lost his long battle with cancer. He was only 55. The park behind the police station was dedicated in his honor. Gov. Craig Benson spoke at the August 2004 grand opening.

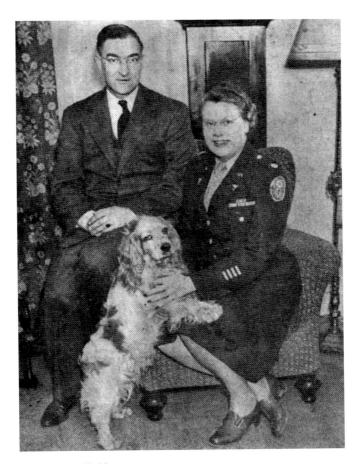

Maj. Elizabeth "Betty" Hill Hay

Imagine crossing the English Channel on June 10, 1944, and crawling onto the Normandy Beaches to set up field hospitals. Capt. Elizabeth Hill Hay was one of the first Army nurses on shore treating the wounded after D-Day.

Hay grew up on the Hi-N-Low Farm in Pelham, taking the trolley to attend school at Lawrence General Hospital School of Nursing. She later became a school nurse in Hampton and Rye, New Hampshire. Hay was responsible for making sure all of the students were vaccinated, thus sparing Hampton from the epidemics that affected other towns.

In January 1943, she entered the Army Nurse Corps, receiving her training at Fort Devens in Massachusetts and Camp Rucker in Alabama. She was sent to England in February 1944.

She and several other nurses boarded a Liberty Ship bound for France on June 6, 1944, D-Day. The women had to climb down rope nets to a landing barge and wade ashore in waist-deep water. Once they arrived on the beaches, they rode in amphibious duck boats to set up their hospital sites.

Eventually, Hay was in charge of three field hospitals. "We worked like dogs, but there was a lot of satisfaction in knowing that we were really doing something at last."

Hay received the Bronze Star for her work at the 42nd Field Hospital and was promoted to major.

Later in the war, Hay led her nurses through a retreat during the Battle of the Bulge. As the Germans advanced, the nurses begged to assist in removing the men. Wearing mud-coated wooler shirts, slacks, and GI boots, the ladies worked hard. As a result, not a single patient was left behind.

Hay received a hero's welcome home and spoke at Pelham's 200th Anniversary Celebration on behalf of returning soldiers. (Courtesy of the Pelham Historical Society.)

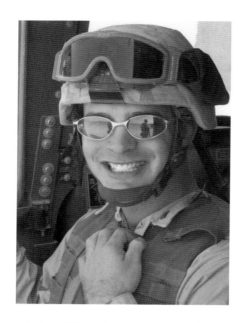

Daniel Gionet

The sign on Main Street reads "Sergeant Daniel R. Gionet Memorial Bridge." Dedicated on June 1, 2013, it honors the 23-year-old Army sergeant killed in Iraq on June 4, 2006.

Raised in Pelham, Gionet enlisted to earn money for culinary school. But after his first tour, he decided to reenlist and train as a medic. He was assigned to 1st Battalion, 66th Armor Regiment, 1st Brigade Combat Team, 4th Infantry Division, Fort Hood, Texas.

In June 2006, he was serving a second tour of duty in Taji, Iraq, when he was hit by an improvised explosive device that detonated near his M1A2 tank during combat operations. The bomb shattered the tank. Gionet tended to the wounded around him, ignoring his own injuries. The medic unit arrived to help, but he directed them to treat the others first. Sadly, Gionet did not survive.

A grieving community turned out to honor his sacrifice. Hundreds of students holding American flags lined the road as Gionet's casket rolled past the schools, and a large flag was draped in the Town Center.

In June 2007, Gionet was honored when the state dedicated a section of Route 4 in Danbury in his name. Designated as the Purple Heart Trail, sections of the road are dedicated to military personnel killed in action.

Pelham's representative Shaun Doherty filed a bill to name a bridge in Pelham in Gionet's honor. After many months, the bill was finally signed into law by Governor Lynch in May 2012.

The bridge on Main Street across Beaver Brook was formally dedicated on June 2, 2013. Gionet is remembered by many for his sense of humor, big bear hugs, and devotion to family. "Danny was just an awesome human being. He was a giver," said Joe Connors, Gionet's high school baseball coach. "He was the first guy to take a new kid under his wing." (Above, courtesy of Denise Gionet; below, courtesy of Cathy Pinette.)

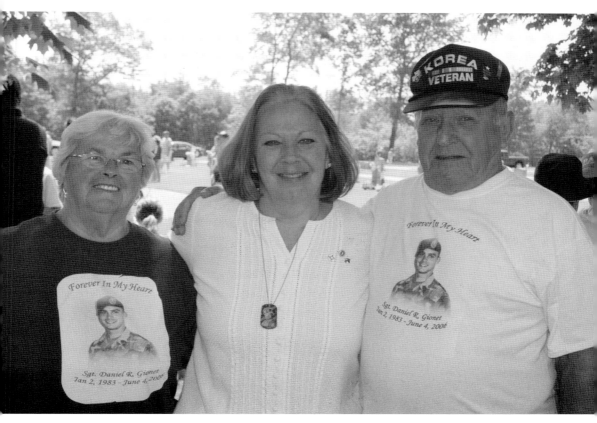

Denise Gionet

After her son's death on June 4, 2006, Denise Gionet felt as though her world had stopped; and yet, life still went on.

Though difficult, Gionet has since made positive changes in honor of her son. She is part of the medical support team in the mental health department at the VA Hospital in Manchester, New Hampshire. One of many Gold Star Mothers, she looks after the injured soldiers who come home.

During World War I, a blue star was hung in the windows of homes for every family member serving in the US military. If the soldiers died during service, a gold star was placed over the blue star, to honor the person's sacrifice. Gold Star Mothers came together to support one another and give loving care to hospitalized veterans. The tradition continues today.

John Steck

John Steck was known as the man who could fix anything. Until the end of his long life, Steck was still actively working his farm, running his sawmill, fixing machinery, and helping others in town.

Born in Nashua in 1914, John and identical twin brother, Charles, were part of the first generation of his family to be born in the United States.

Both boys worked with their father on the family farm atop Jeremy Hill. They started flying planes in the 1930s and enjoyed low-level flying around Pelham.

John and Charles served with the National Guard for nine years before being called into active service on September 16, 1940. In February 1942, they went overseas, landing in Australia. They were sent to different bases in June 1942.

John was the motor transport sergeant of a searchlight battery. Stationed in Australia and New Guinea, he was under attack during the Battle of the Coral Sea in early May 1942.

In 1944, John was reunited with his brother when they both arrived home on a rotation at the Army Ground and Service Forces Redistribution Station in Lake Placid, New York. Neither knew the other would be home. In fact, John left two weeks earlier than his brother, but Charles flew from New Guinea to California and arrived only two days behind John.

For 64 years, John and his wife, LaVerne, raised their family and ran the farm. They never hired help, but instead taught their children how to do the work.

Friends and neighbors called on John to help with sick farm animals or to repair malfunctioning equipment. He was great at fixing things—anything! In the Army, he managed to build a vehicle out of spare parts. He also built a generator that started with the flick of a switch.

John ran the sawmill on his farm, generating the wood for the buildings that he also built himself. He also milled all the wood and helped to construct homes for several other families in town.

A member of the American Legion, VFW, and Farm Bureau, he also served with his brother as a surveyor of wood and lumber for several years. John passed in October 2012. (Courtesy of the Steck family.)

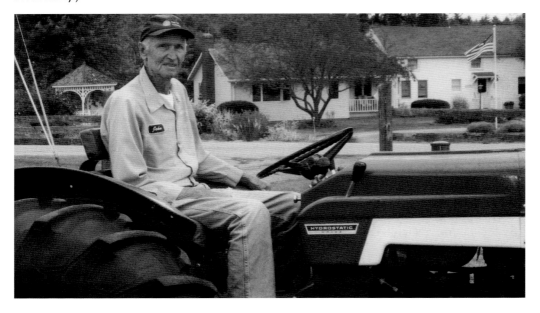

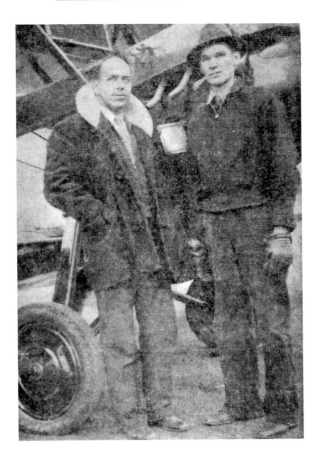

Charles Steck

Growing up as an identical twin can cause problems. There was a time when Charles (above, right) was out to dinner with a lady in Nashua, New Hampshire. The waitress mistook Charles for his brother, and she was very upset to think that John might be "stepping out" on his wife.

Twins Charles and John Steck were born in Nashua in 1914. They worked on the family farm atop Jeremy Hill in Pelham and attended school in town.

Charles is thought to have acquired his pilot's license first, allowing his brother to use it until he got his own. Their low-level flying around Pelham may have bothered a few neighbors. "We harassed the town quite a bit," brother John admitted.

But their pilot skills were in need. As they owned their own plane, Charles and his brother were often asked to assist in rescue missions by local authorities. On one search mission in 1938, Charles and Carl Hirsch (above, left) recovered the body of a missing Hudson man.

The brothers served with the National Guard for nine years before being called into active service on September 16, 1940. They reported to Camp Hulen in Texas, where they trained with the Coast Artillery Corps for 14 months. In June 1942, Technical Sergeant Charles was stationed near Australia and New Guinea, in charge of vehicle maintenance for an anti-aircraft battalion. Charles witnessed the great Army Air Force success at Oro Bay.

"We were always interested in mechanical things," recalled his brother John. "I guess we picked it up on the farm."

Following his service, Charles underwent a long hospitalization and was honorably discharged. Returning to Pelham, he and his brother served as surveyors of wood and lumber for several years. Charles passed away on May 7, 1998. (Courtesy of Pelham Historical Society.)

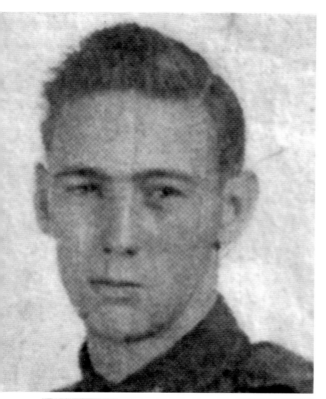

Elmer Goldwait Raymond Jr.

Born in 1920 in Lowell, Massachusetts, Elmer Raymond was an active member of the 4-H club and the Boy Scouts, achieving the Eagle Scout award. In February 1942, he was commissioned a lieutenant in the Air Corps, and served as a flight instructor at Napier Field in Alabama.

In mid-April 1943, Lieutenant Raymond telegraphed his fiancé, 18-year-old Jane Thornber, asking her to come south and get married. Thornber left Pelham on April 22, 1943, arriving to find that her groom-to-be had been tragically killed in a plane crash.

At the 1946 town meeting, Lt. Harry Atwood Jr. made a motion to dedicate the "scout lot" bequeathed by Martina Gage be named the Elmer G. Raymond Park. This tied in with her desire that the land be devoted to the use of the Boy Scouts and 4-H clubs. (Left, courtesy of Pelham Historical Society.)

CHAPTER TWO

A Lesson in Schooling

From the five one-room schoolhouses scattered in the various geographic corners of town, Pelham has come a long way in education. The 1920 junior high building that housed four classrooms was expanded in 1950 for grades 1–8, and named the E.G. Sherburne School. Memorial School opened in 1965, and in the early 1970s, voters approved funds for the town's high school, which opened in 1974. In 2002, New Hampshire's largest elementary school opened, and the E.G. Sherburne school was converted to municipal offices.

Along the way, there has been no shortage of caring, passionate people who wanted the best education for the town's youth.

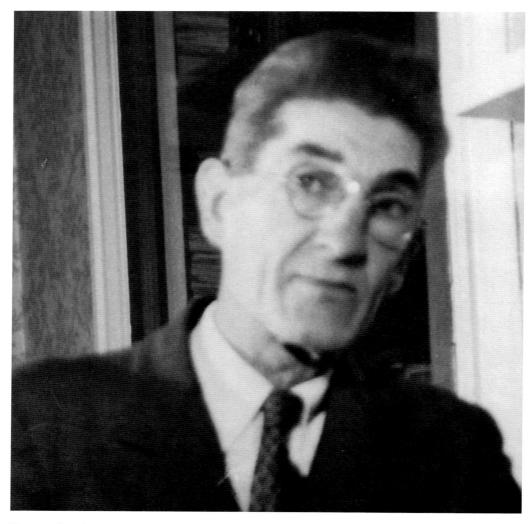

Ernest Gardener "E.G." Sherburne
Born in Pelham in 1885, Ernest Sherburne was well known for his civic and church activities in town. He lived his entire life on the Sherburne Homestead, on Sherburne Road. A skilled carpenter and cabinet maker, he was a farmer by trade and served as a master of the Pelham Grange. Because he was hard of hearing, he could be heard yelling and cursing at his cows from down the road.

For 22 years, Sherburne was a member of the Pelham School Board. He could often be found at the schools fixing windows, shoveling snow, unclogging plumbing or repairing the furnace.

He performed various tasks all over town, and not just for the schools. One day, while fixing the roof on the parsonage, he fell and broke a rib.

He also served as town auditor, chairman of the cemetery trustees, and chairman of the budget committee. In 1948, Sherburne died following a short illness.

Construction of the Pelham Junior High school expansion began on July 5, 1949 at a cost of $57,872. Walter Burton made a motion at a town meeting to name the school for Sherburne to honor his years of service. The town approved, happy to name the school for a man Burton called "of great sincerity and integrity. We should all do well to model ourselves in this example of good citizenship." (Courtesy of Philip Currier.)

Herbert Stanley Currier

For Herb Currier, there were no strangers, just a friend he had not yet met.

Herb Currier reached the lofty age of 100 before passing away in May 1914. A lifelong resident of Pelham, he received the coveted Boston Post Cane at age 96. Started in the early 1900s as a publicity campaign for the *Boston Post*, the canes are passed along to the oldest registered voter in town.

Born December 24, 1913, he attended school in Pelham, and graduated from Lowell High School in 1932. Accepted at the University of New Hampshire, Currier played football and baseball and was a member of the rifle team.

Currier is best known for his service as principal of the E.G. Sherburne School. For years, his smiling face was found in the eighth-grade class picture. He later taught in Littleton, Massachusetts, until his retirement in 1978.

Never one to be idle, Currier spent summers painting houses with Roy Hardy, building with Albert Hirsch, working at the Rockingham Race Track, or delivering mail on the rural delivery route.

For many years, Currier maintained a large garden at his home on Currier Road. Son Philip remembers it well as he was required to weed one long row every day. The abundant produce was often shared with families in need.

Resident William McDevitt remembers meeting Currier. McDevitt mentioned strawberries and Currier immediately brought him to see his garden. Currier then invited him to visit anytime and pick the berries. Currier's generosity, even to those he had just met, was legendary.

The quintessential historian, Currier also possessed the gift of gab. He spent hours researching Pelham History, and telling stories of growing up on the farm. As part of the First Congregational Church choir for 56 consecutive years, he introduced many to the gift of music.

Currier served as selectman, town treasurer, school moderator, a member of the Pelham Volunteer Fire Department, president of the Pelham Senior Citizens, and on the Pelham Council on Aging. With his historical knowledge, he was a key member of the Pelham 250th Anniversary Committee.

In later years, Currier was seen at the Pelham Public Library most mornings, leisurely enjoying the newspapers and doing large jigsaw puzzles. His presence at town events is sorely missed. (Courtesy of First Congregational Church.)

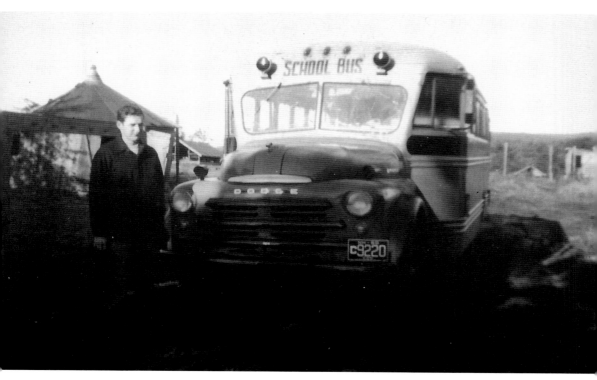

Earl Leonard

Earl Leonard owned and operated the first yellow school bus in Pelham, eventually turning one bus into an entire fleet. (The bus was originally red, but that was quickly resolved.)

Born in Barre, Vermont, Earl moved to Pelham in 1925, purchasing the 140-acre Rocky Snow farm. The property included the land behind what is now Family Dollar, the Leonard Business Center, and Accu-Rate Billiards. He also farmed land across Bridge Street in the Currier Highlands.

In the days before news reports, Earl was known for his ability to accurately forecast the weather. This would prove a great tool in running his business of taking students back and forth to school.

In 1931–1932, Earl was asked to take over transporting students to school in the Currier Highland area. For $2 per week, he took students in his pick-up truck to and from the one-room schoolhouse. The following year, he was asked to pick up a second route, from Pelham Center to the Gage Hill School.

In 1937, Leonard purchased a new Chevrolet Suburban, removed the seats, and put in benches. This served as his makeshift "bus" to cover his route.

Around 1942, Earl purchased his first official school bus. It could hold 24 students and was red. Earl hated red. He went to the local hardware store in town and came home with blue paint, instructing his sons to paint the bus.

In the meantime, the state motor vehicle inspector arrived. "That's nice, Earl," he said, "Except school buses have to be yellow."

Earl said nothing, went back to the store and returned with yellow paint. Not one to waste anything, the wheels and rub rail on the bus remained blue while the rest was repainted yellow.

By 1948, 24-passenger buses were not large enough, and the town wanted something bigger. Leonard bought a 48-passenger bus and bid on the job. Herbert Burton and his 42-passenger Dodge bus also received a contract. However, within a few years, Earl had the contract for all of the school buses in town.

Earl sold the business to his son Russell in 1967, but continued driving until 1970. (Courtesy of Leonard family.)

Russell Leonard

Russ Leonard did not dream of owning a school bus company.

Growing up in Pelham, Russ worked on the family farm and went to school at Currier Highlands No. 5. He was often there early, as it was his job to get the heat going in the building. There were times when Russ would skip classes and head to the farms to work instead.

A curious boy, many of his stories begin with the phrase, "First, you get a skunk." He and his pals had read a book about de-scenting a skunk. With anesthesia ready, they gave it a try. Unfortunately, medical science was not his forte, as the story ended, "We didn't mean to kill it."

He tried to avoid taking over his father's business, taking jobs with Hirsch Brothers Construction or the local quarry. Ultimately, in 1967 Russ took over the business and drove generations of students to school in Pelham. He drove from the time he was 18 until he sold the equipment in 1977.

Russ remembers driving more than just students to school. He began by driving groups of people into Lowell to play Beano, similar to today's Bingo games. These trips expanded into charter trips for local tourists. However, as the big coaches took over, providing passengers with more comfort, Russ was happy to stop the Beano and charter trips.

For years, he was the man in charge of the school buses in Pelham. He knew every road, every hill, and every potential hazard. In fact, the school superintendent relied on Russ to make a snow day call. In questionable weather, Russ would get up at 4:30 a.m. and ride out to the most troublesome spots, such as the hill on Sherburne Road. From there, he would make his decision.

Russ employed many around Pelham as regular and substitute drivers. He also empowered bus drivers to determine acceptable behavior. If an individual student was causing trouble, then off the bus they went.

Now retired, Russ enjoys time with his family. He has a twinkle in his eye as he tells stories of his former mischief. (Courtesy of Leonard family.)

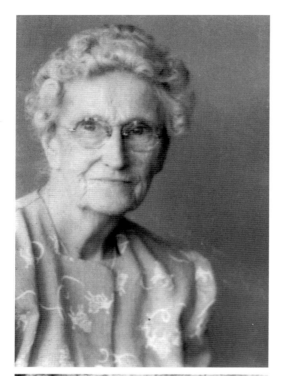

Catherine F. Lee Donovan

Catherine Lee Donovan walked from her home on Mammoth Road to the Gumpas School every day, in all kinds of weather, until her retirement in 1948.

Born in Pelham in 1868, Donovan became a teacher at age 20. She married Stephen Donovan in 1893 and left her position for 28 years to raise her four children. By 1921, she was back teaching at the Gumpas School until her resignation in October 1948 at 80 years of age. She was an active member of the Catholic Women's Club, the Pelham Grange, and the Parent-Teacher Association.

Donovan taught three generations of students. Many went on to college at prestigious schools such as Harvard University and Massachusetts Institute of Technology and even became faculty members. She passed on January 1, 1949.

The dedication of Donovan lives on as an example of an incredibly devoted teacher. (Above, courtesy of Philip Currier, below, courtesy of Dorothy Carter.)

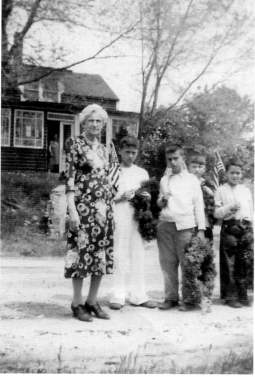

Eleanor Herbert Burton

Eleanor Burton recalls how, on any given morning she would walk up the dirt road to visit with her friend May Sherburne. Times were slower, there was no morning news blaring from televisions, cars did not fly down Sherburne Road at 40–50 mph, and people still wrote notes. "Things are certainly different now," says Eleanor.

Born in Dracut, Massachusetts in 1922, Eleanor Herbert met Donald Burton in high school, watching him play in baseball games. Eleanor recalls that many women married their boyfriends before they were sent overseas for World War II. While in the process of receiving her nursing training, she left for Florida to get married too. Luckily, her husband never left the country, remaining at Eglin Air Force Base.

Husband and wife moved to the farmhouse on Sherburne Road, raising three children, including twin girls. At the time, everything was in the center of town—the church, library, post office, general store, and the Grange. When someone needed help or asked for volunteers, Eleanor's hand was up.

"It was what you did," she says.

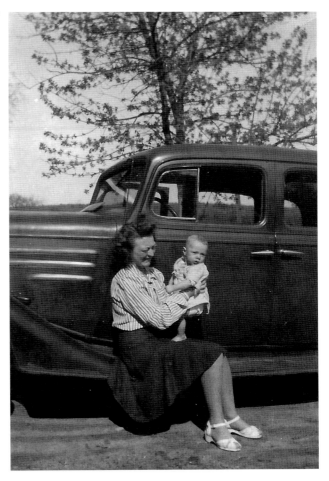

Claiming that her community service was not particularly unique, she explains that everyone would pitch in to help with wherever was needed. Nevertheless, Eleanor seemed to go that extra mile.

When most others would be content to stay home on cold New Hampshire nights, in 2009 the 87-year-old woman was serving on the school board as chairwoman. For her efforts, she received the Champion for Children Award from the New Hampshire Association of School Administrators.

For over 55 years, she has been a part of the Girl Scouts. For her commitment, Eleanor was honored in Old Home Day Parades.

In 2012, she received the VFW Loyalty Award for endless hours spent giving to the town of Pelham. The town's 2009 Annual Report was dedicated in her honor.

At age 92, Eleanor can't always do everything she would like, but her handwritten notes are still savored by their recipients. She still remains involved in the town. VFW post commander Mark McCabe once stated that the town was "quite fortunate to have a resident that truly exemplifies the meaning of community, commitment and volunteerism and has made a tremendous impact." (Courtesy of Eleanor Burton.)

Velma L. Houle
Everyone remembers Velma Houle's famous peanut butter cookies. For 35 years, Houle served the Pelham School District. From 1957 until her retirement in 1985, she was the school lunch director. Under her untiring leadership, the lunch program, which originally served 50 students, grew to provide lunches for over 1,400. The program became one of the most successful in New Hampshire and served as the model for many other school districts.

Houle grew up in Pelham and was very active in town activities. If there was food involved, Velma was usually in the kitchen, making things happen. At local grange events, her entries often placed first in every category.

Her "secret" cookie recipe (below) was always in demand. Watch out, it makes a lot of cookies! (Both, courtesy of Eleanor Burton.)

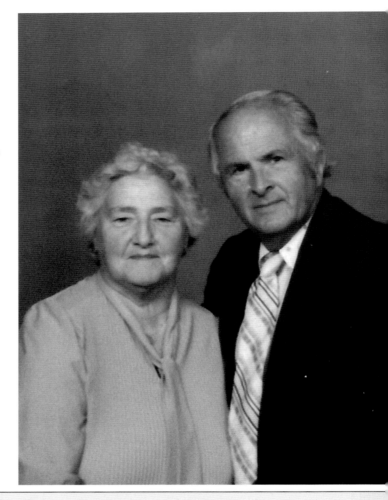

" *14 lbs peanut butter*

5 lbs Honey

3 lbs butter

From the school lunch program 1950 – 1985 Velma Houle, retired food service director.

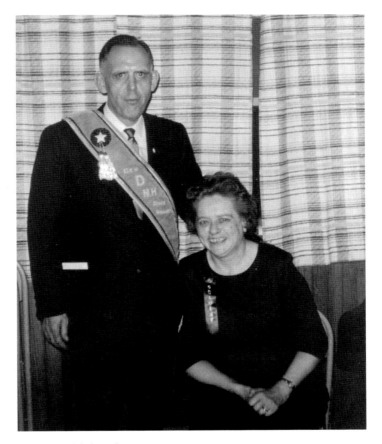

Ruth Eleanor Brooks Richardson

Two crabapple trees along the Village Green memorialize longtime, well-loved teacher Ruth Richardson. Though she had no children of her own, she inspired Pelham students of multiple generations.

Born in 1920, Richardson had polio as a child. She had to overcome great obstacles to become a teacher, relearning how to walk and write. Her twisted hands made it difficult to hold pencils or chalk, so she held them between her first and middle finger to write. Her students recall that, despite the condition of her hands, Richardson "had the most beautiful penmanship."

In 1943, she married Randall Richardson. Upon moving to town, she and her husband became very active in the Grange, at the local and state levels.

Richardson began teaching in Pelham in 1948. Her knowledge of New Hampshire folklore was impressive and she brought in many guests to enrich her classes with their experiences. Her love of history led her to be one of the original officers of the Pelham Historical Society.

Unable to perform teacher chores such as bus duty, Richardson worked with attendance and registers instead. She quickly demonstrated her efficiency and organization skills and began handling community relations on behalf of the school. Her skills included counseling parents and students with great effectiveness and tact.

Because of her physical condition, two students were chosen to help her walk her down the hall. "It was always an honor for us to walk with her," recalls one student. Another student who entered her fourth-grade class after the school year had begun remembers Richardson helping her through the transition.

In 1972, Richardson was one of six outstanding teachers across the state to be honored by New Hampshire governor Walter Peterson. (Courtesy of Philip Currier.)

Harold Mooney

Harold Mooney was one of the volunteers responsible for making a Pelham high school a reality. Born in 1919 in Pelham, he attended South Eastern Louisiana College, and later joined the US Marine Corps. During World War II, he was master technical sergeant. After the war, Mooney went on to receive his vocational teacher's training at Fitchburg State.

With 32 years of service as an Instructor of manual arts at Leominster Vocational School, Mooney received several awards, including the Massachusetts Teachers Association District Service Certificate, the Outstanding Service Award from the Leominster Trade School Home Building Program, and the Suesse Chalet Outstanding Teacher Award.

Mooney was always looking to help others. Every year, he and Donald E. Burton would work with students to build a house in Leominster. In 1955, he was part of the group that restored the bell at the First Congregational Church.

In 1972, Mooney was part of the curriculum committee for a proposed high school in Pelham, along with then school committee chairman Philip Currier. Pelham students were being sent to Alvirne High School in Hudson at a cost of $975 per student, per year. This cost, along with the fact that Alvirne would no longer accept Pelham students after September 1974, pushed the town to build its own high school.

The one-story school was to be built on a 70-acre site with a full-size gymnasium. Voters were asked to approve a warrant article for $2.5 million for construction.

For his endless work in support of the high school, Mooney received a certificate of appreciation. He passed at his home in November 1999. (Courtesy of Eleanor Burton.)

Debra Laffond

"You know the question: 'If you weren't a teacher, what else would you do?' I always wanted to be a children's librarian," says Debra Laffond.

Known to all as Miss Debbie, Laffond joined the Pelham Library in 2006 as the children's librarian. Though not from Pelham, the former preschool and kindergarten teacher has made a profound difference in the lives of children in town.

Miss Debbie reintroduced regular story times, with different groups to serve various ages. After 25 years of teaching, she has lots of experience encouraging young readers and creating fun activities.

When children reach age six, Miss Debbie makes their first library card a very special milestone. She knows all the children that visit regularly and is able to recommend books to capture their attention.

Every summer, children sign up for the reading program, reading books for prizes, eating ice cream sundaes, and spitting watermelon seeds. A popular event is Big Truck Night. Miss Debbie persuaded local businesses to bring their big trucks and heavy equipment and let the visitors explore them. "How exciting is it to have an opportunity to see these things up close, be able to ask questions, maybe even touch or sit in one of these vehicles!"

And she does all of this with a shoestring budget of $500 per year and lots of help from parents and volunteers.

In 2013, a surprised Miss Debbie was named New Hampshire Children's Librarian of the Year.

"Debbie's dedication, creativity and passion for children's services shows in every aspect of her work," said former library director Corrine Chronopoulos, who nominated Laffond for the award. "Here in Pelham, we have known for a long time what a treasure Debbie Laffond is, and what extraordinary children's services she provides."

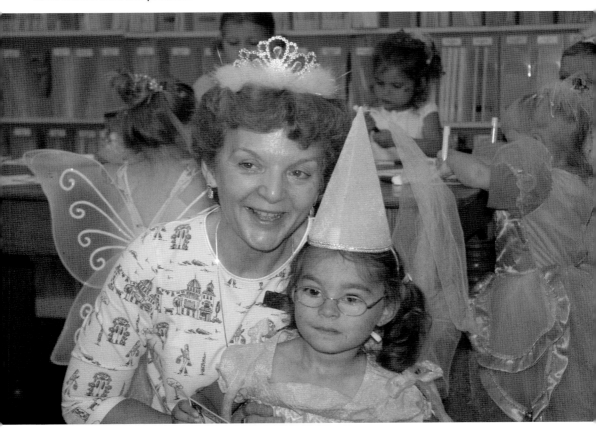

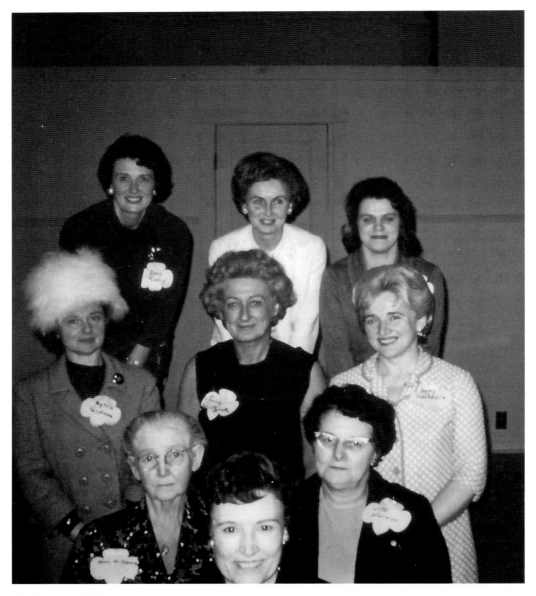

Catherine "Kitty" Harmon

Born May 29, 1914, in Springfield, Massachusetts, as Catherine Stebbins, Harmon served in the US Navy during World War II.

In 1936, she married Ralph Harmon, a real estate agent. The mother of two daughters, Carole (Hutchinson) and Janice (Spence), Kitty was a very active adult member in the Merrimack River Girl Scout Council.

Harmon (pictured bottom right) was also a member of the First Congregational Church, the League of Women Voters, and the Pelham Grange.

She is most remembered for her attention to marching. For a short time, she led the Sherburne School Band, making them practice endlessly before their appearance in the parades.

Jane Provencal

Remember the Jump Rope club at Sherburne School? Jane Provencal, pictured with her mother, Eleanor Burton, wanted kids to simply stay active. For over 20 years, Provencal worked for the Pelham School District. She served as a long-term substitute teacher and later became the elementary school physical education teacher.

A lifelong Pelham resident, Provencal has always been passionate about health. She remembers practicing baseball with her father, Donald Burton, as he coached the local team. (Courtesy of Jane Provencal.)

Sherburne School Band

In January 1959, the short-lived Sherburne School Band put on its first demonstration. They marched in the Old Home Day Parade in August and played for the eighth-grade graduation the following June. The all-volunteer band featured all kinds of instruments.

With no official music program, parents made uniforms for the students. Girls wore white pleated skirts and blouses with black ties. Boys wore white pants and shirts, and white sneakers. Gold and royal blue capes completed the uniforms. (Courtesy of Eleanor Burton.)

Barbara Campbell

For over 25 years, Barbara Campbell has been the "heartbeat of Pelham High School." In 2013, she was selected as New Hampshire's School Nurse of the Year.

Campbell puts her heart into the job, literally. She has survived two nearly fatal episodes of cardiac arrest. Her life was saved by those whom she taught CPR skills.

Born in Lowell, Massachusetts, Campbell graduated from Lowell State College in 1974. She idolized her older sister, who was a nun. But, "I liked boys and fashion too much, so the next best profession to me was nursing," says Campbell. Her first job was a nurse's aide in a nursing home in Lowell. After graduation, Campbell worked as staff and head nurse at Lawrence General Hospital for two years.

She and her husband, Glenn, moved to Pelham in 1976. From 1976 to 1988, she worked with Lowell Visiting Nurse Association, working with single mothers to teach them to care for their newborns. In 1988, Campbell became the school nurse at Pelham High School.

Rather than simply look after students who felt poorly, she sought to educate them about self-care. Campbell believes she has the role of teaching kids at the most impressionable stage of their lives how to take good care of themselves, what questions they need to ask their doctor, and how to advocate for their own health care.

With this philosophy in mind, Campbell taught CPR skills. She pushed to make coaches and teachers become certified in CPR so they could save lives if needed.

Little did she know it was her own life they would be saving. On October 27, 2005, Campbell collapsed in her office from a heart attack. A teacher and Pelham police officer, trained by Campbell, were able to administer CPR and save her life.

Despite being in a coma for a week, Campbell was back at work within six weeks, and she was not slowing down. She led the school community and town in an effort to raise funds for automated external defibrillators for all the district schools and town buildings.

Despite a second heart attack two years later, Campbell is still going strong. In fact, encouraged to seek further education, she became a nationally certified nurse in 2009. Certainly not for the faint of heart! (Courtesy of Barbara Campbell.)

CHAPTER THREE

Pelham Is a Playful Town

Racing has been a part of Pelham's history as long as there have been cars and tracks. Pelham is home to many successful drivers, builders, and sponsors of various kinds of cars.

But it is not just racing. In 2014, Pelham was designated a Playful City by KaBoom! for the second year in a row. A national nonprofit group supported by the Humana Foundation, KaBoom! recognizes communities that make play a priority and use innovative programs to get children active, playing, and healthy.

The credit goes to the many volunteers in town: parents who give their time, local businesses who sponsor teams, and residents who get involved. Together, they have created a community that provides kids with a fun, safe environment to learn sportsmanship, teamwork, and commitment.

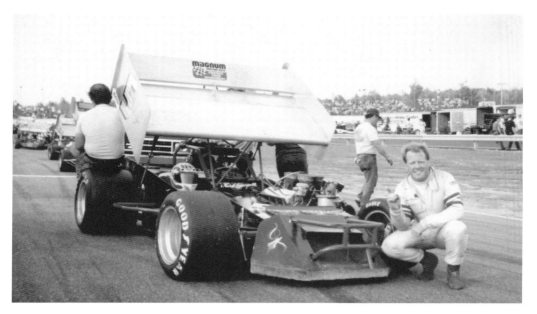

Nate Boutwell Jr.

When he was younger, Nate Boutwell Jr. was inspired by his father, Smokey Boutwell, pictured below with his first racecar in the late 1950s. Nate wanted to drive racecars, or maybe be a rock star.

Racing won out. Boutwell started on local tracks and moved on to bigger races. During his own career, he won two season championships in the Ultra Fast Super Modified Division at both the Star and Lee Speedways.

Boutwell now owns his own welding shop in town. He loves building cars and still follows the racing world. (Both, courtesy of Nate Boutwell Jr.)

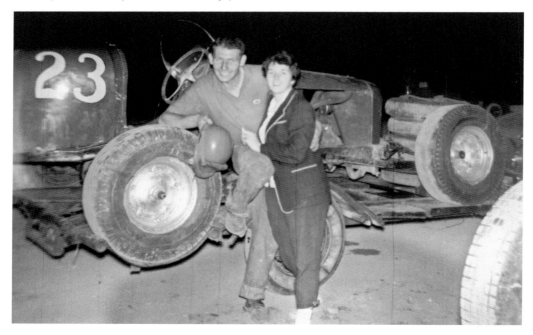

Robert C. Blinn

A native of Lowell, Massachusetts, Robert Blinn was involved with Pelham Little League for 23 years, serving as president for 15 years.

Blinn dedicated countless hours making the George M. Muldoon Park one of the most visited parks in the state of New Hampshire. It is home to the Pelham Little League, Pelham Softball, and Razorback Football.

Blinn brought baseball to a whole new level in Pelham. He determined that no child would ever be turned down from playing ball; everyone was given a chance.

"You could not refuse him," said his friend Ed Gleason. "He was so intense, you had to respect him." Blinn would also never ask anyone to do something he would not do himself, and he never asked for any recognition for his efforts.

Despite a gruff exterior, it was well known that Blinn would do anything "for the kids." In 2006, he brought the Challenger Division to Pelham, which allowed kids with disabilities the opportunity to enjoy playing baseball.

It was always the kids that made everything worthwhile for him; that, and soft-serve ice cream. One of his favorite things to do was to take his grandson Logan to water the fields at Muldoon and then over to the former Hillside Country Store for soft-serve ice cream.

"Sure we did Disney, but with Bob, it was always the little things," said daughter Melissa Rickards. "He lived for the kids, they brought him to life. And soft-serve made him happy."

Sadly, after a battle with cancer, Blinn passed in November 2009 at the age of 53. Even after his diagnosis and treatments in 2008 and 2009, Blinn never stopped working to ensure that Pelham Little League had a great year. The 2010 baseball season was dedicated to him, with every uniform bearing his name. (Courtesy of Melissa Rickards.)

Christopher and Kristen Mader

Many in New England grew up pond skating during winter months. Parents Chris and Kristen set up an ice pond in the yard of their Pelham home, teaching their kids to skate, play hockey, and enjoy outdoor winter activities.

Inspired by the NHL Winter Classic and a documentary called *Pond Hockey*, the Maders started to wonder—what if they could bring an outdoor rink back to Pelham? A similar project had been rejected a few years earlier, and Pelham had not seen an outdoor rink since the 1960s.

Chris spearheaded the effort in November 2008, writing a business plan and presenting it to the Board of Selectmen. He then asked residents to donate time, money, and resources to make the dream into reality. Over $6,000 was raised, enough to build a 100-foot-by-50-foot ice rink in the center of town at Lyons Park. On January 3, 2009, the Pelham Ice Garden, named for the Boston Garden, was born.

For his efforts, Chris Mader was recognized during a Bruins game on January 23, 2010, as the Boston Bruins Community Captain.

Pelham Parks & Recreation Department later took over the maintenance of the Ice Garden. Mader remained president, which included building and maintaining the ice rink, managing volunteers, organizing the day-to-day activities at the rink, coordinating activities with the Pelham Parks & Recreation Department, and fundraising.

The Ice Garden hosted a pond-hockey league, the Pelham Winter Carnival, and the annual Fire & Ice Classic. Members of the Pelham Fire and Police Departments played against each other to raise money for CHaD, the Children's Hospital in Dartmouth, New Hampshire.

"Building and maintaining this rink was a true team effort, a testament of what can happen when the town and residents of the community work together," says Mader.

Unfortunately, the Ice Garden did not have enough support to open for the 2013–2014 winter season, though residents look forward to continuing the outdoor tradition. (Courtesy of the Mader family.)

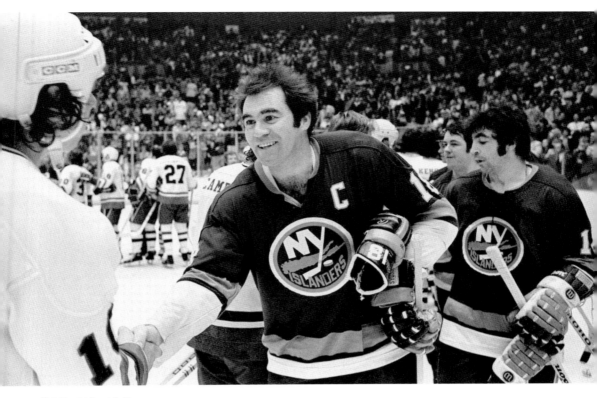

Eddie Westfall

Eddie Westfall was responsible for the popularity of ice hockey in Pelham in the early 1970s. Born in 1940 in Canada, Westfall made his home in Pelham in 1969, with his wife, Joan Ann, and their four children. He rebuilt a house along Beaver Brook, spending his days tearing up old houses for pieces to refinish the inside of his home. The Westfall family lived in Pelham from December 1968 until 1985.

Westfall played with the 1970 and 1972 Stanley Cup Champion Boston Bruins and was known for his abilities as the "penalty-killer." He also scored the second of three of the fastest goals in National Hockey League history—three in 20 seconds. He was named to play in the All-Star Game in 1971, 1973, 1974, and 1975.

In 1972, after 10 years in Boston, the Bruins right wing was lost to the NHL's expansion draft. Westfall went on to become captain of the newly formed New York Islanders. He scored the team's first goal and led the team to the Stanley Cup semifinals in 1975.

But Westfall was much more than just a hockey player. Very involved in the community, he and other members of the Bruins would appear at local charity events, signing autographs and greeting local residents. In 1972, Westfall served as chairman of the New Hampshire Easter Seals and enjoyed one of the most successful fundraising seasons to date.

Westfall played 1,226 career NHL games, scoring 231 goals and 394 assists. Following his retirement in 1979, he became the Islander's "color analyst" for the SportsChannel until 1998.

In November 2011, Westfall was inducted into the Islander's Hall of Fame; he called the second period of the game that night between the Islanders and the Bruins. (Courtesy of Barry Westfall.)

Brendan "Woody" Wood

Born in Lowell, Massachusetts, Brendan Wood moved to Pelham in 1970. He began his automobile repair shop along Nashua Road in 1971, working from his home. Initially, he rented a garage, but after a few years he was able to build the current Woody's location. It was just Woody and one town truck to start. These days, with all kinds of trucks in his arsenal, Woody performs full-time towing services for the New Hampshire State Police, as well as the police departments for the towns of Pelham, Windham, and Salem. He holds several certifications related to towing and auto repair, including industrial waste handling.

But it is not all work for Woody. He has taken advantage of New England winters to engage in snowmobile racing. He had a factory-built drag race sled, and enjoys racing on snow and grass all over the country.

Community is important. He and his business are proud supporters of the local police and firefighters associations, the Good Neighbor Fund, Pelham Baseball, the Pelham Community Spirit Group, the schools, and several other organizations. When Debra Laffond began her "Touch a Truck" events at the Pelham Public Library, Woody was right there. He brought all kinds of vehicles, large and small, allowing the children to climb, explore and blast the horns.

Some of the most interesting work comes when Woody donates "miscellaneous forms of transportation" to the town. This might include moving light poles, generators, trees—heavy stuff. But when you own the kind of equipment that Woody has, you get asked to remove an unfortunate moose from the roads or trucks from walls.

When times are tough, and vehicles are not performing the way they should, Woody is very generous in helping those in need. His business is the epitome of service. (Courtesy of Woody's.)

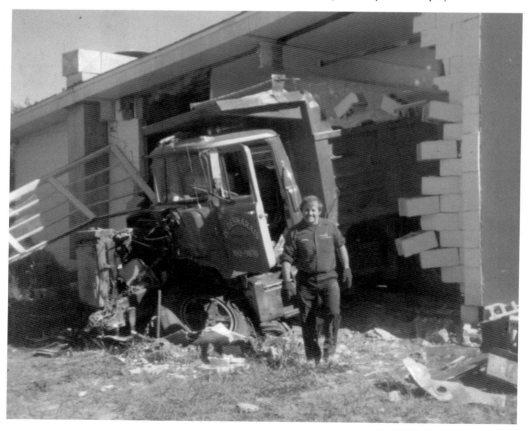

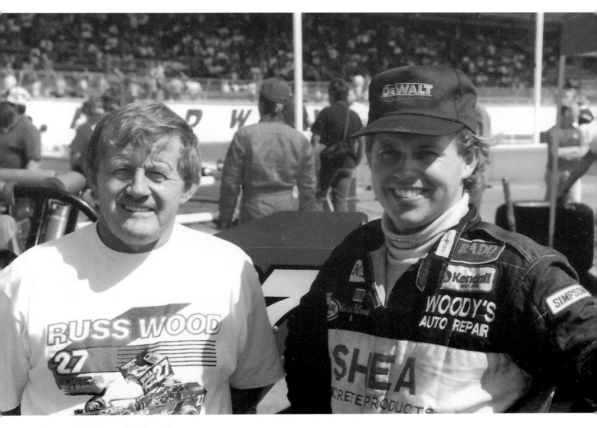

Russell "Russ" Wood

The son of Brendan Wood, Russ Wood was born in Pelham in December 1963. He grew up around cars, and as a result, he is a partner in Woody's Auto Repair & Towing with his father and brother Brian. With years of experience, he holds several certifications in the towing and automotive industry as well as in the heavy-duty truck category.

But Russ's love is the race world. He initially raced snowmobiles from 1976 to 1981. After that, it was cars. He has been all over the country—California, Arizona, Florida, the Midwest, throughout New England, and even into Canada.

He races "supermodifieds," which are the fastest short track racecars in the world, according to Russ. He has over 100 career supermodified feature wins.

It is one thing to race and win, but if you beat some of the legends in the race world, it is a sweet victory. Russ has beaten Tony Stewart at Cayuga Speedway in Canada, and Jeff Gordon at Lee Speedway and Thompson Speedway. He even had Paul Newman drive one of his cars.

Along the way, there are bound to be some bumps. But in a supermodified, those bumps can lead to serious injuries. Russ recalls one of the worst accidents in September 2013, at the Star Speedway Classic in Epping, New Hampshire. The rain held off during the 48th running of the prestigious classic. Shortly after the halfway mark of the race, near turn four, Russ was heading almost straight into the wall. The hard crash brought the red flags, and Russ was taken to the hospital with leg injuries. No doubt his wife, Lisa, and two children worry about Russ' safety.

Russ is currently taking the 2014 season off from his own racing, but he is still very involved. His son Russell Jr. has taken up the sport and is an up-and-comer on his own.

"In traveling the country, we have had a great time seeing all the states. There are a lot of road stories we could certainly tell," says Russ. (Courtesy of Woody's.)

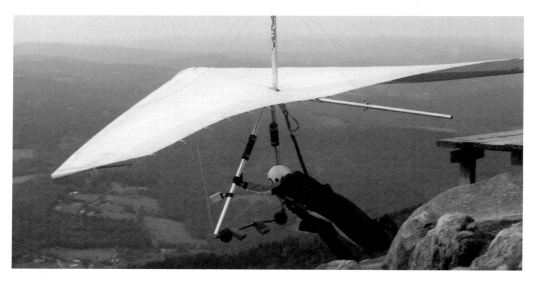

Colette Carson

Only a handful of females held a master pilot rating in the world of hang gliding 20 years ago. Colette Carson, a Pelham resident for over 22 years, was a pioneer. Even now, only about 10 percent of pilots are women.

Flying was not Carson's idea. Soon after college, her friend convinced her to take a hang gliding course at the University of Massachusetts at Lowell. They were the only women in class. Immediately hooked, Carson went on to receive her Master Rated Pilot certification.

For over 20 years, Carson has taken to the air as often as possible. She has been across the country, flying in Tennessee, Telluride, Colorado, upstate New York, and all over New England. Sometimes her flights take her so high, she is required to wear oxygen. Carson has seen the earth from over 17,000 feet in the air. (Both, courtesy of Colette Carson.)

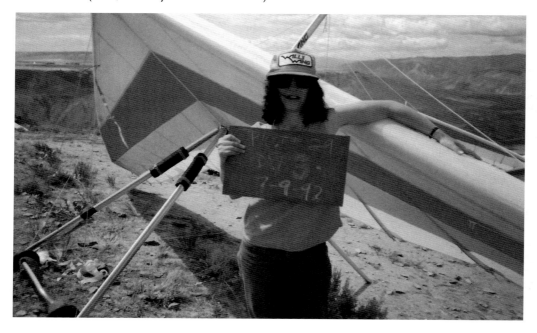

Fishing Derby & Boat Race

Little Island Pond is its own community within the town of Pelham. Originally a collection of summer houses and camps, the residents began to live in the area year round. Committees formed for fire fighting, water safety, fireworks, and get-togethers.

In the mid-1990s, the Little Island Pond Association sponsored an annual children's fishing derby. Children and parents would meet at the designated camp for weigh-in of their prized fish. Winners were awarded trophies.

Residents also participated in an annual boat parade. People donned costumes and decorated their boats. A committee of judges chose the best as the boats cruised the perimeter of the lake. (Both, courtesy of Cathy Pinette.)

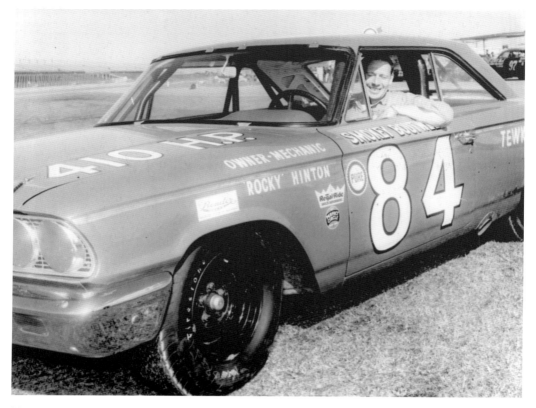

Nathan "Smokey" Boutwell

With a long list of racing accomplishments, Nathan Boutwell was inducted into the New England Auto Racers Hall of Fame in 2005. He raced and won in just about every kind of vehicle—from modifieds, supers, midgets, or spring cars. His "never quit" attitude led to a series of victories.

The Boutwell family has a long history in Pelham, tracing back to the Wyman family, some of the first settlers in town. Boutwell served as a Marine in the Korean War, working in the motorpool. He was the personal driver for a high ranking colonel. Back in the United States, he found his way to a racetrack in South Carolina. A driver failed to show up for the race, and someone asked, "Is anyone here a driver?" Boutwell got his first chance to drive a racecar, and was instantly hooked.

"Smokey," as he was called because of the cigarettes and cigars constantly hanging from his mouth, started racing at the local speedways in New Hampshire in the late 1950s. He quickly went on to bigger races, winning over 200 races in his career.

As with all racecar drivers, Smokey had his superstitions. He never allowed a photograph of himself before a race with his eyes open. Otherwise, he believed it would be the picture "right before he died in the race." He had his trademark red driving suit and infamous Hush Puppy shoes, and he would not wear matching socks.

Though superstitious, Smokey was fearless. He was famous for being able to drive the Duggan 1/3, which was said to be the worst handling car. Only Smokey knew how to handle it, and win.

Smokey's favorite car was No. 84, made with an all-aluminum Corvette engine. The car dominated the track, and in 1964, Boutwell drove it in the Daytona 500. He came in 20th place, right behind Ralph Earnhardt. The engine, made only for one year, was later banned by NASCAR for being too light.

In 1969, Smokey retired at age 37. He took up flying airplanes and running a welding shop. He served on the board of selectmen. Well known and well liked, Smokey passed in 1993. His name is still respected in racing history. (Courtesy of Nate Boutwell Jr.)

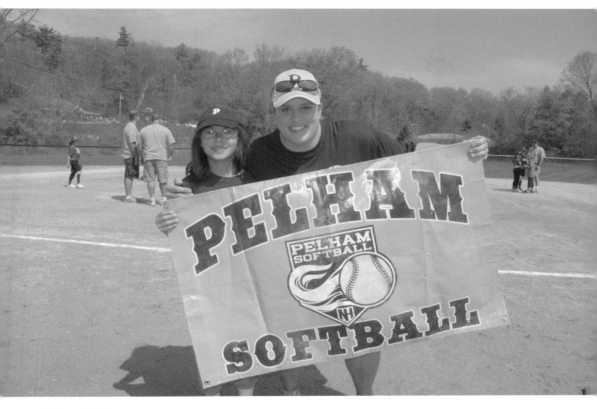

Deborah Ryan

When Deb Ryan was younger, she drove along Mammoth Road in Pelham and spotted a house that she wanted. Little did she know that years later, that house would become hers.

Born in Winchester, Massachusetts, her passion is softball. Ryan has played, coached, or been involved in the game for the past 40 years. She spent her youth on the west coast playing at a higher level, and even receiving a college scholarship. With eight-hour road trips, she experienced the bonding and camaraderie that goes with being part of a team.

She wanted to bring that team spirit to the girls of Pelham. Prior to 2010, softball was part of Pelham baseball. Ryan and others started Pelham Softball, of which she serves as president.

She teaches the girls to win, but never at a cost to their self-esteem. Everyone plays, despite their ability level. Ryan wants every girl to give 100 percent, not just for themselves, but for the team. "The girls have so much potential. I want to raise the bar for them."

Because of her involvement with so many community events, Ryan is recognized all over town. She can be found serving as a cakewalk hostess at a school fundraiser, softball coach, basketball coach, spelling bee judge, field trip chaperone, and dedicated mom. She is also involved in the town's anti-drug organization, the Pelham Community Coalition.

Ryan works tirelessly on behalf of all kids in Pelham. A founding member of ACES (Awareness for Community Education and Support), she has served on the Pelham School Board since March 2009. Three years ago, Deb Ryan was quoted as saying, "We have the power to create the change we want, if we are willing to work for it," and she did. Most recently, she led the successful effort to pass a warrant article for a $22.6-million upgrade and addition for Pelham High School.

The N.H. Association of School Administrators awarded Ryan with the 2014 Champions for Children Award.

Her love for the town is incredible. "I am a Pelham addict," she proudly proclaims.

Brian Johnson

The challenge was to offer a wide range of healthy activities to satisfy a community of all ages and interests, find space around town to hold events, and all with a small budget. Brian Johnson rose to the task around 2008 when he accepted the position of Pelham Parks & Recreation director and has been successful.

Pelham was selected as one of 217 Playful Cities designees across the country in 2013, and won the title again in 2014. In 2013, the department was recognized by the National League of Cities for reaching goals in the "Let's Move Cities, Towns and Counties" initiative.

Johnson recently secured grants and funds for new playground equipment at the Veterans Memorial Park. He is now working with the school district to collaborate on nutrition, including healthier options at concession stands.

Johnson credits the many local residents who help out. "It's a truly wonderful group of volunteers in every program, every different organization." (Courtesy of Brian Johnson.)

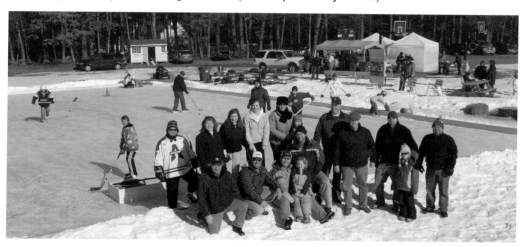

CHAPTER FOUR

Governing a Town

All politics is local in New Hampshire. Pelham residents still take pride in town meetings and their voice in the governing of town matters. This includes reviewing and discussing the budgets of town officers, which has caused some conflict over the years.

Pelham has traditionally sent at least one representative to the State House in Concord to speak for town interests. But even on the town level, there are those that have served in elected or appointed roles for several years. They understand the inner workings of town politics and strive to meet the needs of a growing town while maintaining the conservative, small-town nature of Pelham.

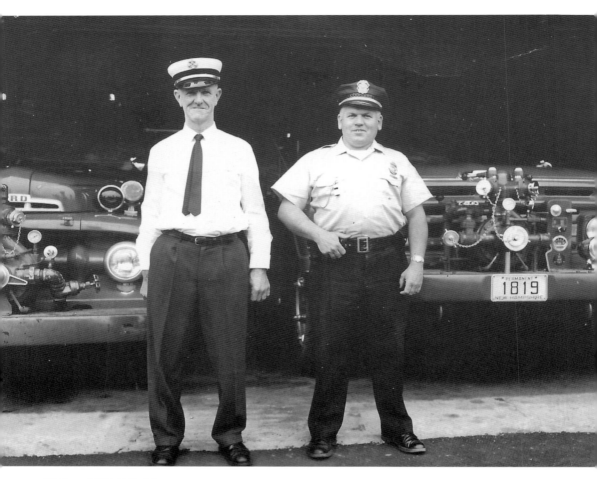

Richard Mansfield

No one ever had anything negative to say about Richard Mansfield. Born in 1910 in Pelham, Mansfield was the fire chief for the town for 36 years. Even at his retirement, Mansfield was only a part-time employee.

Mansfield joined the force when he was 16 years old. The department had three vehicles: two model A's and a Model T. For years, the fire department consisted of only the chief and many on-call volunteer firefighters.

Over the years, he shared a police-fire office with Chief Ralph Boutwell. Mansfield's wife, Harriet, would answer the phones for both departments. People in town joked that Harriet didn't need the telephone; she could be heard just fine without it.

For years, Mansfield used his own car to carry men and equipment to emergencies. He was almost never reimbursed. Until 1962, he received no salary, being paid only for specific services. "Mansfield just about donated much time and he was never fully compensated," according to Boutwell.

After 50 years of service, the chief and his wife retired in 1977. He passed away in 1994. (Courtesy of Pelham Historical Society.)

Phillip C. Currier

For almost 35 years—a record—Phil Currier has served Pelham as town moderator. Born and raised in the Currier Highlands, he is one of several generations of the Currier family in Pelham.

Currier attended the University of New Hampshire and graduated from Boston College Law School. His practice is based in Nashua, New Hampshire, and involves mostly real estate, wills and trusts, probate, and estate law.

With a love of politics and government, it was natural for Currier to be involved in the New Hampshire State Legislature. He served three terms in the 1970s, and was elected as a delegate for Pelham in two Constitutional Conventions, in 1974 and 1984. He was chair of the school board when plans were made to build the high school.

An Eagle Scout himself, Currier is asked almost every year to be part of the Court of Honor ceremonies for Pelham's Troop 25 and 610. He gives the Eagle Charge, challenging the scouts to continue their good works. His son Philip is a Troop 25 Eagle Scout.

Before Little League had fields at George

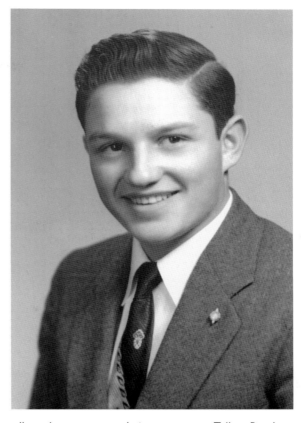

Muldoon Park, for over 20 years the Curriers allowed teams to use their property on Tallant Road.

But it is his role as moderator— both at the town and school level—where Currier is most recognized. He has presided over scores of meetings, both traditional style and SB 2 ballot-votes. He takes pride in recognizing people to speak by name and allows everyone to have their say.

Currier remembers moderating one particular town meeting where Father Ed Richard was seated along the back of the room with the fire department. Richard raised his hand to speak, but Currier didn't see him. The discussion ended, and Currier moved on to the next issue.

"Point of order," said Richard. He explained that he had missed speaking on the previous issue. "Maybe you should stand up next time," said Currier. "I was standing up!" People in attendance broke into laughter, and it became a regular joke between Currier and Richard.

At Richard's 60th birthday party, Currier and his wife, Priscilla, selected a decrepit old stool from their barn, and packaged it up. They presented the gift to Richard. "If you want to be recognized at town meeting, stand on this!"

Along with his sense of humor, Currier is known for his charitable donations to the town. He was also the head of the 250th Anniversary Celebration, runs the First Congregational Church Old Home Day auction, and speaks often at town events. (Courtesy of Philip Currier.)

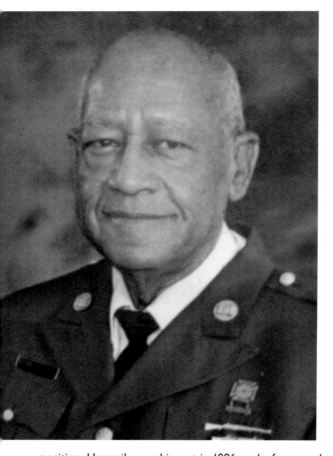

Paul Scott

Paul Scott moved to Simpson Mill Road in Pelham in 1976. The artist wanted a short commute to work painting signs at Hammar & Sons and a great town to raise his family.

But at the end of Scott's street, Stanley Roketenetz had been granted a town contract to dispose of local waste, which, over time, had been expanded to include waste from Seabrook Nuclear Facility. Ordered by the State Public Health Department in 1974–75 to operate a sanitary landfill, it was clear to Scott and others that the company was not in compliance.

What started as no more than 10 trucks per day increased up to 60 trips up and down the road. The trucks, ignoring their 2:30 closing time, traveled quickly on the back road, dropping waste as they passed.

Scott was concerned. After school, his kids rode their bikes on the street and were finding medical waste on the road.

He was no politician, but Scott knew that the dumping was hurting his family and his neighborhood. He and his wife, Josie, took their complaints to town hall, showing up at selectmen meetings. Eventually, Selectmen investigated the claims, and further dumping was terminated.

Following this victory, neighbors encouraged Scott to run for a selectman position. He easily won his seat in 1996, and a few months later, was appointed to be vice chairman.

Unfortunately, the damage was already done. Scott lost his wife and two of his sons to disease. He and his daughter, Gail Scott-Key, strongly believe that the waste from the dump had leached into the drinking water, causing his family to succumb to illness. Others from that part of town also claimed there was something "funny" about the water.

Over the years, Paul Scott continued to create art and has had his work featured in an exhibit at the Pelham Public Library. He moved to Nashua and, despite the fact that he was losing his eyesight, he loved to work with students, his nieces, and grandkids to learn more about art. (Courtesy of Gail Scott-Key.)

Thomas Kirby

Scholar, scientist, soldier, and engineer: that is how Tom Kirby referred to himself. With his untiring volunteerism, dedication to his community, engineering achievements, and educational background, his service to Pelham was legendary.

Born in 1935 in Milford, Massachusetts, Tom Kirby was an accomplished electrical design engineer with Sylvania Corp—later GTE—in Needham for 32 years. He was a direct participant in the design of advanced communication systems in the engineering field and was awarded four US patents during his career.

He served three years active duty in the US Army Signal Corps and retired after 28 years with US Army Reserves as a lieutenant colonel. He received seven military awards, including the Meritorious Service Medal.

He served 15 years on the Pelham Budget Committee and was a charter member of the Pelham Technical Staff, which brought Pelham "online" with its first computer system. This required connecting wire between the buildings. Generally regarded as a serious man, residents were amused to find that he and Bill Scanzani had shut down the road one morning, and both men were hanging on poles like monkeys, physically stringing the wires.

Kirby was first elected to the State Legislature in 1993, where he served two terms before he passed away in August 1996.

His legacy lies along Windham Road. The Kirby/Ivers Town Forest, which includes 22 acres from the Ivers family, was named for him in honor of his work in forest management planning. His program is currently used to encourage wildlife and forest growth on Pelham Conservation Lands.

William McDevitt

Moving around a lot as a child certainly makes one long to put down roots as an adult. Such was the case for Bill McDevitt, who moved 11 times as a child, and 9 times after he married Joyce. But when he moved to Pelham in 1971, he knew he had finally found a home. "I knew I was in a community when people recognized me by name in the supermarket," he said.

He and Joyce had lived in town for about two years when she became ill. The doorbell rang, and it was a neighbor delivering a home-cooked meal for his family. He decided then that it was time for an active role in such a generous community.

In 1974, he was elected as a library trustee. In this role, McDevitt became accustomed to standing up at town meetings, arguing for more funds for the library staff. At the time, the director made about $2.50 per hour. McDevitt would make impassioned pleas for a minimal 25¢ an hour raise.

He went on to serve on the board of selectmen. However, he was not elected for his first years in the position. In June 1991, the phone rang. Charlotte Moore, a member of the selectmen, had received resignations from two board members, Ralph Boutwell and James Hardy. She asked if he would be interested in interviewing for the position. McDevitt was chosen to fill one of the seats.

When the term was up, he ran for reelection and won. "I don't think anyone really knew who I was," he says. He was at the polls, but no one came up to congratulate him. At that time, the elections were often hotly contested, and it was customary for the candidates to host a party after the election—to either gloat or mourn. McDevitt had no such party. "I would not have known who to invite," he joked.

He certainly could throw a party now. Since 1974, McDevitt has served Pelham on many boards and committees. He has participated with the 250th Anniversary Committee, Community Spirit Group, Sherburne Hall Committee, Garden Club, and served several terms as a selectman.

Philip Currier provides the perfect summary: "Bill is a good friend and a real asset to our community." (Courtesy of William McDevitt.)

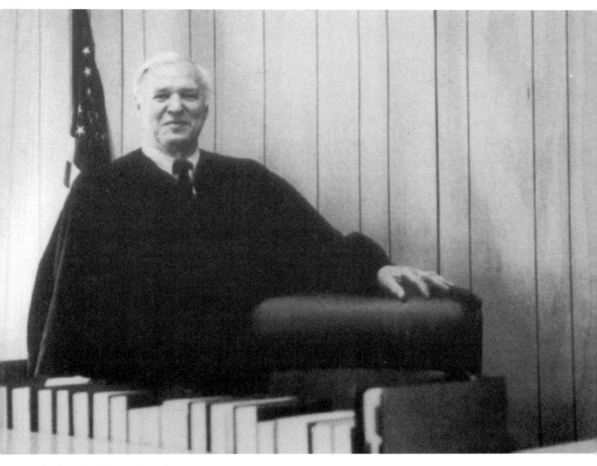

Judge J. Albert Lynch

J. Albert Lynch wanted to go to medical school. However, he was "bewitched" by a young lady, who later became his wife. She persuaded him to go to law school instead. Lynch attended Boston College Law School and went on to represent various clients, including members of the Demoulas family.

Appointed to the bench in 1955, Judge Lynch adjudicated thousands of civil and criminal disputes during his career. With his characteristic common sense, wit, and down-on-the-farm wisdom, Lynch brought his own sense of justice to each case, even when listening to some of the wildest excuses ever brought before the bench.

Judge Lynch had the honor of being Pelham's first planning board chairman, and also served the town as the town counsel. He operated a law office in Nashua and a dairy farm off Castle Hill Road in town.

In Pelham, the Pelham Municipal Court was located on the second floor in the former town hall (now the VFW hall). From here, Judge Lynch held night court sessions until April 1992, when he retired from the bench.

A strong supporter of the Boy Scouts, Lynch was instrumental in helping the town acquire additional land for Raymond Park, as well as the "Mills" property for Pelham's municipal center. He purchased the property and held it until the town approved spending the funds to purchase the land.

A founding member of the Pelham Historical Society, Lynch was instrumental in converting the collection of glass plate negatives donated by Joyce Mason's family into paper and digital formats for the town. He did so in the memory of Joyce, who served as his clerk of court for 10 years. (Courtesy of Pelham Historical Society/*Reflections*.)

Shaun Doherty

As a young child, Shaun Doherty told one of his teachers that he would be president some day. There is still plenty of time.

Born and raised in Pelham, Doherty graduated Pelham High in 2009 and immediately sought political office. He was one of youngest state representatives to be elected. One of his most notable accomplishments was having a bridge named after Pelham veteran Daniel Gionet. On June 1, 2013, the bridge on Main Street was dedicated to Gionet thanks to Doherty's persistence.

But he has always been about community service. For his Eagle Scout project, Doherty moved the old library collection (and categorized every book, magazine, video, and DVD) to its new home on the Village Green.

In 2046, Doherty will be the chair of Pelham's 300th Anniversary Celebration. At the suggestion of Charlotte Moore (pictured), he was appointed in 1996 at the 250th Celebration by Chair Philip Currier. (Above, courtesy of Linda Doherty; below, courtesy of Charlotte Moore.)

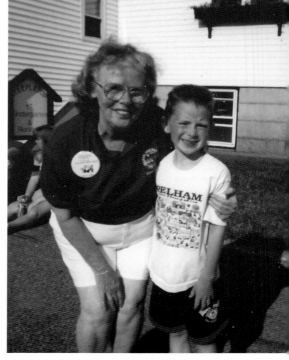

CHAPTER FIVE

Just Doing My Job in the Most Extraordinary Way

In Pelham, people have seen the town grow in ways they never would have imagined. Many town and private employees have taken the initiative to expand their positions to meet the growing need.

Whether they contributed with their friendly smile, experience in their positions and knowledge of the town, or the desire to do the right thing, those who took those extra steps have raised the bar. Few are willing to take credit for their accomplishments and outstanding service, saying that they are just doing their job.

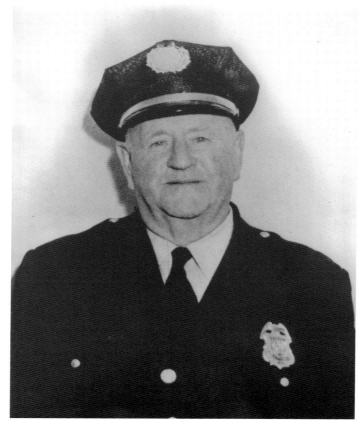

Arthur Peabody

A lifelong resident of Pelham, Constable Arthur Peabody was the first chief of police.

The position was created in 1923, but did not come with an office or a vehicle. Chief Peabody worked from his home, with his daughter Hilda Richardson taking calls. Dispatch calls came in through Nashua on the police radio.

For many years, he used his own car to go on calls. In the 1940s, St. Patrick Church donated the first of two cruisers in town, with the other coming from the Pelham Police Relief Association. The town finally approved the purchase of the first police car in 1961. The initial budget for the police in 1923 was $5.25. When Peabody retired in 1960, after 37 years of service, the budget had increase to $4,727.85.

Peabody was old school. He knew that kids got into trouble, but didn't think it made them "bad." If he caught a student skipping school, he might bring out the handcuffs as a scare tactic, but then he would bring the student home, letting the parents handle the issue.

During one incident, the Leonard family asked Peabody for help to learn who had been draining gasoline from the hay baler. They sat out one night and caught the culprit in the act. Peabody brought the boy to his car and told him to get in. The boy slid across the back seat, climbed out the door on the other side, and went home. Peabody let it go, and there were no more incidents.

Peabody also served as prosecutor, selectman, moderator, and cemetery trustee. He was the chairman of the town's 200th Anniversary Celebration in 1946. After retirement, Peabody remained active, serving in the New Hampshire State Legislature for seven terms, even submitting bond legislation to sponsor the "new" Pelham High School in the early 1970s.

After Peabody passed in 1979, town forestland off Old Lawrence Road was named in his honor. (Courtesy of Pelham Historical Society.)

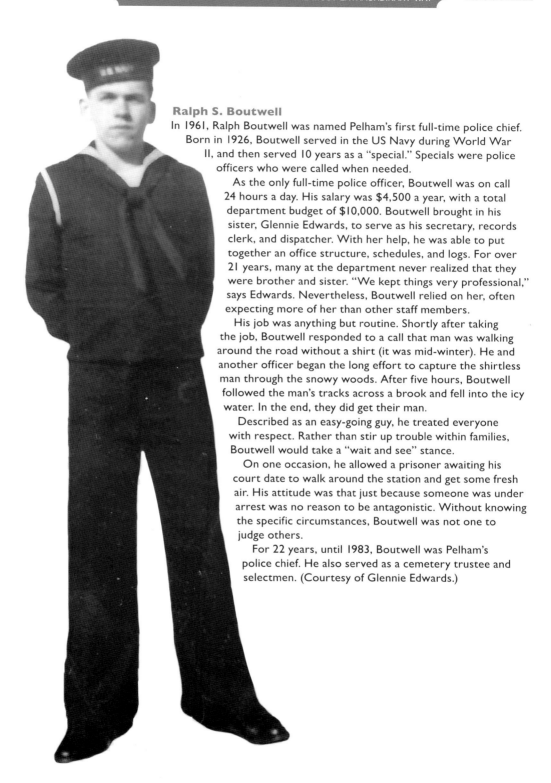

Ralph S. Boutwell

In 1961, Ralph Boutwell was named Pelham's first full-time police chief. Born in 1926, Boutwell served in the US Navy during World War II, and then served 10 years as a "special." Specials were police officers who were called when needed.

As the only full-time police officer, Boutwell was on call 24 hours a day. His salary was $4,500 a year, with a total department budget of $10,000. Boutwell brought in his sister, Glennie Edwards, to serve as his secretary, records clerk, and dispatcher. With her help, he was able to put together an office structure, schedules, and logs. For over 21 years, many at the department never realized that they were brother and sister. "We kept things very professional," says Edwards. Nevertheless, Boutwell relied on her, often expecting more of her than other staff members.

His job was anything but routine. Shortly after taking the job, Boutwell responded to a call that man was walking around the road without a shirt (it was mid-winter). He and another officer began the long effort to capture the shirtless man through the snowy woods. After five hours, Boutwell followed the man's tracks across a brook and fell into the icy water. In the end, they did get their man.

Described as an easy-going guy, he treated everyone with respect. Rather than stir up trouble within families, Boutwell would take a "wait and see" stance.

On one occasion, he allowed a prisoner awaiting his court date to walk around the station and get some fresh air. His attitude was that just because someone was under arrest was no reason to be antagonistic. Without knowing the specific circumstances, Boutwell was not one to judge others.

For 22 years, until 1983, Boutwell was Pelham's police chief. He also served as a cemetery trustee and selectmen. (Courtesy of Glennie Edwards.)

Dorothy Hardy

For over 25 years, Dot Hardy was the voice on the Pelham Police airwaves, dispatching the officers to various parts of town.

Born in August 1921 in Lowell, Massachusetts, Hardy graduated from Lowell High School in 1938. Despite losing her husband, Roy, in 1965, independent Hardy raised her six children alone. She managed to work part-time as a dispatcher, work as a news correspondent for *Lowell Sun* and *Nashua Telegraph*, and take care of her family.

She is best known as the voice on the phone, handling the emergency line. She could actually resolve some domestic disputes by just talking to people on the telephone. With her blunt honesty, she was able to mediate difficult situations. She also served as a part-time police officer, in charge of female prisoners.

Hardy loved working for the police department and being so involved with the community. As supervisor of the Pelham Voter Checklist for 37 years, she got to know all the residents, both those existing and the newcomers. She knew the people, where they lived, and how to get to their homes.

At her retirement party in 1995, former chief Ralph Boutwell said the town had not needed a 911 computer system to assist officers on calls as Hardy knew how to direct his officers to a home, from the street name down to what kind of dog was in the yard.

And she still had time for the community. Hardy was a founding member of the Pelham Good Neighbor Fund, a member of Pelham 250th Committee, and served on the budget committee.

She was very sensitive to the needs of others. In fact, it was her reputation as a second mother to many on the police force that prompted her and others to start the Good Neighbor Fund.

She passed in August 2009, at the age of 87. Friends and neighbors say that Hardy's legacy lives on in her accomplishments in the community.

Hardy is pictured below standing next to Chief Boutwell. (Courtesy of James Hardy.)

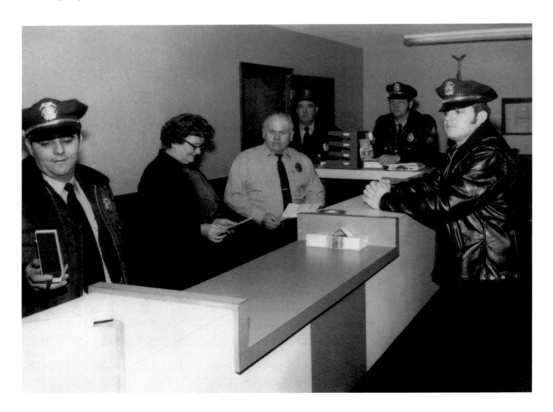

James A. Hardy

Sheriff Jim Hardy has been a member of the New Hampshire law enforcement community for more than 30 years.

Hardy was born in 1958 in Pelham. A New Hampshire State Representative from 1979 to 1983, Hardy has also been a member of the board of selectmen and budget committee.

With strong encouragement from his mother, Dorothy, Hardy began his career as a police officer in Pelham. He had no idea how exciting it was going to get. In August 1980, he was involved in a police pursuit of three brothers who had just robbed the Cumberland Farms in neighboring Hudson, New Hampshire. As the description of the car was broadcast over the police radio, Hardy picked up the chase going south on Mammoth Road near Mercury Lane.

As the pursuit continued, the suspects tossed out firecrackers, hoping to slow Hardy down. Then they began firing shots, one of which hit the windshield. Hardy got splattered with fragments of glass, but kept up with the suspects. Eventually, as the car got to Lowell, Massachusetts, Hardy was able to force the brothers off the road where they were arrested after a struggle. Hardy was lucky to walk away with only facial cuts.

Soon after this incident, Hardy joined the Hillsborough Sheriff's Office in 1981 as a deputy sheriff. He advanced through the ranks of Sergeant, Lieutenant and Captain. In 2002, Hardy was elected to his first term as Sheriff, and continues to hold the position.

Friendly and outgoing, Hardy takes his position as Sheriff seriously. He credits his great staff for the work he is able to do, adding that he is always able to call on his former boss for advice when needed. (Courtesy of Jim Hardy.)

Louis Fineman

A former dairy farmer, Louis Fineman was born in Pelham in the late 1900s. His parents ran a 25-head dairy farm, but his mother died when he was 13 years old. The youngest of six children, Fineman found himself running the farm when his father became seriously ill soon thereafter.

The Pelham Bank was the idea of Leo Kahn, president of Purity Supreme Inc., which operated 42 supermarkets and 19 drugstores. In 1971, Kahn recommended that Fineman, then the bank director, be named president.

Although Fineman had no formal banking education, the bank was very successful, paying dividends most years that he was president. In 1983, it had profits of $3 million, as good as any other bank in New Hampshire.

His "folksy touch" made Pelham Bank a success. Fineman could be found at the bank before it opened, helping employees count deposits. His office was up front, separated from teller's windows only by a glass panel. But rather than sitting and pouring over financial reports, Fineman would be talking to customers about crops or family, opening savings accounts or haggling with depositors over their rates. He would never let a depositor take their money elsewhere—he would find a way to match or beat their interest rates.

Unlike larger banks, Fineman was also able to bend the rules when needed. In one instance, he arranged for a short-term loan for a customer who needed emergency access to his certificate of deposit several weeks before it matured. Fees were almost nonexistent.

Fineman also cared about the community, and was very generous. Through his professional and charitable efforts, he became one of Pelham's most successful business leaders, serving as founder and president of Pelham Bank and Trust. (Courtesy of Neil Fineman)

Joyce Mason

Born in Lowell, Massachusetts, in 1929, Joyce Mason was the personification of Pelham. Joyce worked for the Pelham Police Department as a dispatcher and served as clerk of court for Pelham Municipal Court from 1982 to 1992.

A tireless volunteer, Mason was a Sunday School teacher, a Girl Scout leader, a member of the Ladies Auxiliary of Pelham Square and Compass Club, Ladies Fire Auxiliary, Pelham Community Spirit and the Sherburne Hall Restoration Committee. She also served as supervisor of the checklist and a justice of the peace from 1975 until her passing in 2006.

Active in the town's 250th Anniversary Celebration, Joyce was one of the authors of the town pictorial history book *Reflections*. Upon her passing, her personal collection of photographs, taken by Molly Hobbs, was donated to the historical society. One of her prize possessions, the 73-plate collection of glass negatives depicts Pelham scenes from the 1890s to the 1920s. (Courtesy of Glennie Edwards.)

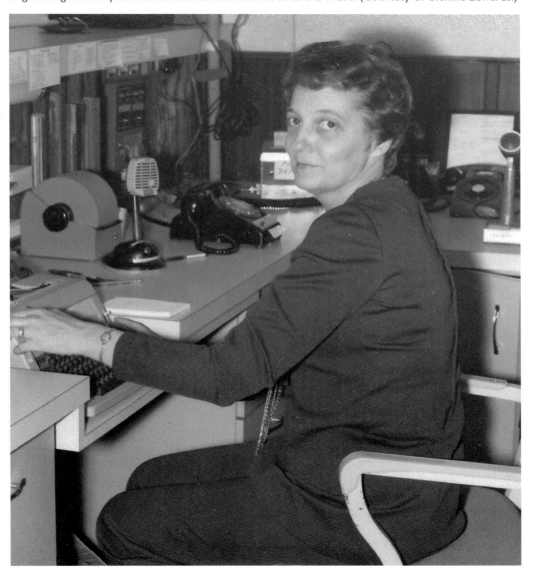

Glennie Boutwell Edwards

It would be easier to list the things that Glennie Edwards has not done in her 80-plus years.

With incredible curiosity and enthusiasm, Edwards continues to be very active in the community. The list includes Pelham Garden Club, Red Cross counselor, New England Banjo Yankee Strummers, Conservation Commission, New Greeley Singers, Sherburne Hall Committee, 250th Anniversary Committee, certified police officer, assessor, reporter, snowmobiling, drawing house plans, car racing, quilting—it goes on. As of this writing, she is working on the prize quilt for the 2014 Old Home Day celebration.

Born in Pelham in 1933, Edwards was sent to live in Portsmouth, New Hampshire, when her father died. The ten-year-old girl stayed with her aunt and uncle, who worked multiple jobs, leaving her to attend school and care for her young cousins. After five years, Edwards returned to Pelham with an independent streak; no one was going to tell her what to do.

She had a "blast" teasing the Dracut police with her driving skills. Told that she drove "like a guy," at age 15, Edwards started racing modified stock cars at the Dracut speedway. She met Andy Cody and adopted his "just try it" attitude. "If it can't be done, I'll do it right away. If it's impossible, it might take a couple of days more."

Her mother had taken over her father's interior design and painting business, so Edwards took up sewing, creating slipcovers and draperies. She also worked as a reporter for the Manchester Union Leader and the Dracut Dispatch.

In 1961, her brother, Pelham police chief Ralph Boutwell, asked her to work with him. As the first full-time police chief, he needed a dispatcher. She started with secretarial work, then added dispatch and records clerk. In fact, she created the system for logging calls. Unfortunately, there were only funds for the dispatcher position. For years, Edwards did three jobs but was only compensated for one.

Edwards was working at the former station when it was hit by a car in 1978. She felt the building shake from the impact. Realizing what happened, she started laughing. She radioed Boutwell, but had difficulty talking through her laughter. Luckily, no one was hurt.

In 1986, Edwards left her position at the station, and went to work for the Concord Prison System as a financial clerk. She retired after eight-and-a-half years. Edwards remains very active in the community. (Courtesy of Glennie Edwards.)

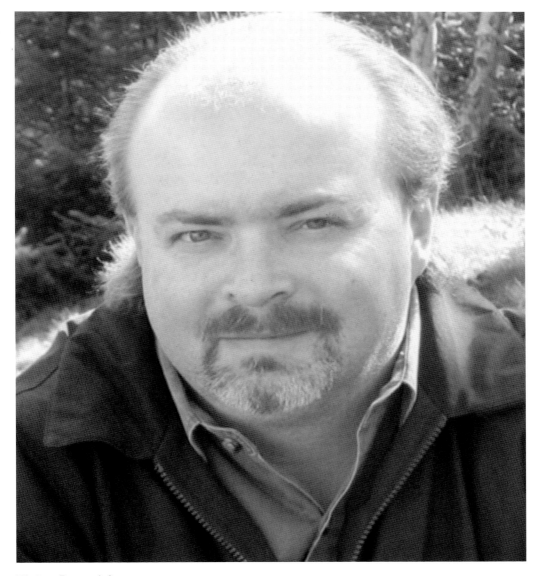

Victor Danevich

For a small town, Pelham has state-of-the-art technology. The police and fire departments have cameras strategically located and computers in each police car. Danevich's incredible technology plan provides for continuous upgrade of all town systems.

Victor Danevich, an "unheralded hero," is responsible. If something breaks or there is a question about new technology, Danevich is there. He is always making sure that everything works as it should for the benefit of the community. (Courtesy of Victor Danevich.)

James Greenwood

Jim Greenwood's family traces back many generations in Pelham. Chances are good that everyone is somehow related to him.

Best know for his work on the local cable access channel PTV, Greenwood is often found bringing electronic equipment around town, getting ready to film a parade, a graduation, public meeting, or musical concert.

Greenwood was born in 1960 and was part of the first freshman class at the new Pelham High School. He joined the Army in 1979, choosing helicopter repair as his career field. He had training in Alabama and later spent time in Alaska.

In 1994, Greenwood was employed in the precision sheet metal field. A pile of metal fell on his leg and he was out of work for five years. While he recovered, he spent time volunteering with CTAC, the community technical committee. When Ron Bourque left PTV, Greenwood volunteered to learn the job. The 30-hour-per-week cable coordinator position eventually became a full-time job. Within the first few years, Jim was already saving the town money by doing the audio work that had previously been subcontracted out. Now, residents count on his coverage of local town events, especially for concerts and graduations where seating may be limited.

In the late 1990s, Greenwood created the first town message board as a forum for residents to discuss school issues. People working odd hours or stuck at home (especially in poor weather) were able to get information about upcoming events, discuss issues regarding election questions, or organize a class reunion. Discussion on the board could get heated. It was not uncommon for threads to go on for several days and many pages. Greenwood spent a significant amount of time moderating the board.

Things are always shaking for Greenwood, sometimes literally. During the selectmen's meeting on October 16, 2012, Pelham experienced an earthquake. When Jim reviewed the footage, he realized the shaking was caught on camera. He sent the film to the local news, who included it in their broadcast.

As technology continues to change, Greenwood is always seeking to bring new ideas to town. (Both, courtesy of Jim Greenwood.)

Therese Soucy

If you have had business with St. Patrick Church in Pelham, then you have met Therese Soucy. An institution at the church, Soucy has served as business administrator for 24 years and for the St. Patrick School since it opened in 1993.

Therese has seen all six of her children get married at St. Patrick, and almost all of her grandchildren have been baptized there. (Courtesy of the Soucy family.)

Sister Mary Goodwin

Loved by many, Sister of Mercy Mary Goodwin ran the St. Patrick Church Religious Education Program.

God certainly watched over her. On an excursion with Father Ed Richard, Sister Mary was in a moving car when the door opened. Hanging on to her strap, she leaned out to close it. Father Ed was very concerned. "I was fine," said Mary. "I had my strap on." However, she had been holding her pocketbook strap and not the seatbelt! (Courtesy of St. Patrick Church.)

Father Edward D. Richard

Popular and well regarded by the parishioners at St. Patrick Church, Father Ed Richard served as pastor for the parish for 12 years.

After attending school in Lowell and St. Mary's Seminary in Baltimore, Maryland, he was ordained in Manchester in 1968.

Upon arrival his arrival at St. Patrick's in 1988, he found a parish $1.2 million in debt. With the help of key parishioners, he led the drive to eliminate its debt, including completing payments for St. Patrick School. He also worked hard on capital improvements for the church, including a new roof on the rectory, heating systems, and fixing windows.

Father Ed served as chaplain of the Pelham Police and Fire Departments. He was well known and liked by all, including younger parishioners. Generous with his staff, he frequently took them on excursions to acknowledge their hard work and dedication.

One parishioner recalls his most memorable sermon. On one of the hottest days of the year, Father Ed stood to deliver his talk. He walked up to the podium, and stated, "If you think it's hot here, you should see what Hell is like." With that, he sat back down. Message received!

Unfortunately, in the 1990s, allegations of sexual abuse were made against many priests across the country. Father Ed was caught up in the scandal when one such allegation against him came to the attention of the New Hampshire Attorney General. The diocese was told that an investigation of Father Ed was pending and encouraged his removal from St. Patrick. He was placed on administrative in April 2002.

No one in Pelham believed any of the allegations. In fact, several residents created a "We Care" fund to assist with any legal defense for Father Ed. More than $5,000 was raised through various events, including an "Island Night." Sadly, there was no investigation, and no exoneration for Father Ed. The diocese allowed him to retire and collect his pension. (Courtesy of St. Patrick Church.)

Georgiana Rondeau Bedard
Motherhood is a full-time job, especially when raising 17 children. Georgiana Bedard and husband Arthur moved to Pelham in 1918 to a home with no electricity or running water. Bedard managed, doing all the canning and baking and making clothes for all of her children.

In 1960, she was named "Mother of the Year" in the Greater Lowell Area. Around Pelham, the saying was, "If I didn't have a mother, I'd want her for my mother."

This photograph below shows all of the Bedard children: (first row) Arthur Sr., Jackie, Georgiana, Skee, Dickie, Ronnie, and Arthur Jr.; (second row) Carmen, Gertrude, Simone, Germaine, Rena, Lorraine, Rene, Emile, and Raymond; and (inset) baby Murial ("Teechie"). (Both, courtesy of Jackie Blanchette.)

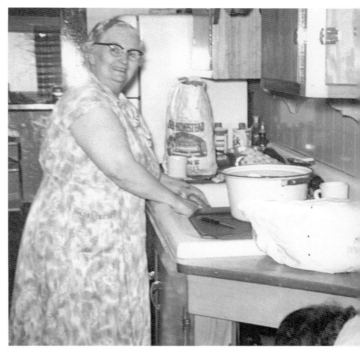

Ron Bourque
The director of the local cable access channel (PTV), Ron Bourque also hosted a show called *Cable Talk*. Bourque was outspoken with his opinions on town issues, and the show was the subject of much controversy and discussion in Pelham. Before his departure, he was able to work with Jim Greenwood, his successor at PTV. (Courtesy of Jim Greenwood.)

William H. "Red" Gibson
When Red Gibson moved to Pelham in 1974, he and his business, Pelham Plumbing, easily became fixtures around town. The charter member of the Friday Morning Club, it was the perfect opportunity for him to spin yarns or share a good joke.

From May 1998, he worked as Pelham Cemetery Sexton, making improvements in the town's seven cemeteries. Treating everyone with dignity, he made difficult decisions a little bit easier. Gibson passed in January 2007. (Courtesy of First Congregational Church.)

CHAPTER SIX

Many Helping Hands Make Light Work

Most people have experienced some kind of tragedy—a fire, unemployment, prolonged illness, or other sudden loss. Pelham has never shied away from helping its neighbors in need. The generosity of the folks in town is legendary.

Many are ready to raise their hands whenever a job needs completion, all to make Pelham a better community. Residents are ready to go to work, whether it be fundraising, planting gardens, setting up holiday displays, or just giving of their expertise and time.

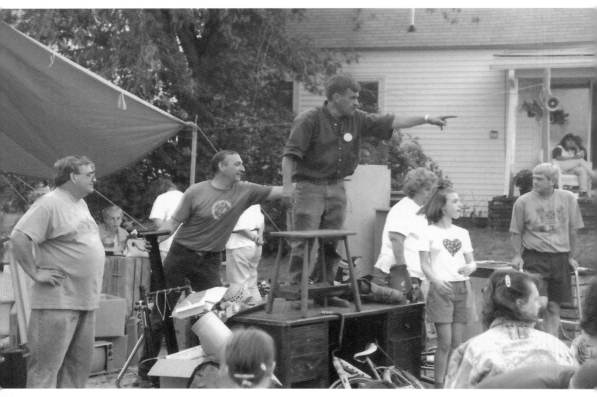

Victor Spaulding

One of the most popular events of the Annual Old Home Day celebration is the auction named for Victor Spaulding, the auctioneer for many years. On the big day the crowd gathers to bid on a range of items, from furniture to tools to household decorations.

Born in 1950, Victor and his twin, George, built a trading post when they were 13 years old. In fact, the plan was to build an entire pilgrim village. Inspired by their fourth-grade history class and the photographs of forts, houses, and trading posts, they decided to build some of their own. They filled a swamp area using their father's tractor to construct their buildings. The project was appropriate, considering that Spaulding's family was descended from Pelham's first settler, Deacon John Butler.

As a route mail carrier for years, Spaulding was a familiar face to all in town. In 1986, he served as chair of the 250th Anniversary Committee and was a member of the capital improvement committee.

In 1983, Spaulding was elected to the board of selectmen, where he served two terms before moving to Stark, New Hampshire in 1986. Even after his move to Stark, Spaulding returned to Pelham every year to serve as auctioneer for the Old Home Day, helping to make the event a financial success. He was the face of the Old Home Day auction.

After his death in 1996, he was honored at the New Hampshire Municipal Association's annual conference for his voluntary effort and dedication to town government. (Courtesy of First Congregational Church.)

Frank Sullivan—Good Neighbor Fund
The Pelham Good Neighbor Fund was established in 1969 to provide food and financial assistance for less fortunate residents. Frank Sullivan has been with the group since 1974, serving as president since 1978.

Through the years, dedicated volunteers have engaged in fundraising events to raise money for the fund. They have to provide support for hundreds of families, including rent, heat, electricity, and food.

"It is in giving that you receive," says Sullivan.

Committee members served as the marshals in the 2013 Old Home Day Parade.

Shown from left to right are (first row) Chuck Curtis, Linda Pace, and Karen Fournier; (second row) Mary Ann Roche, Jimmy Roche, Priscilla Pike-Church, Nancy Vachon, Frank Sullivan, Cheryl Brunelle, and Darlene Michaud. Missing from the photograph are Dennis Hogan, Ann Marie Lacharite, and Gerty Sousa (Both, courtesy of Frank Sullivan.)

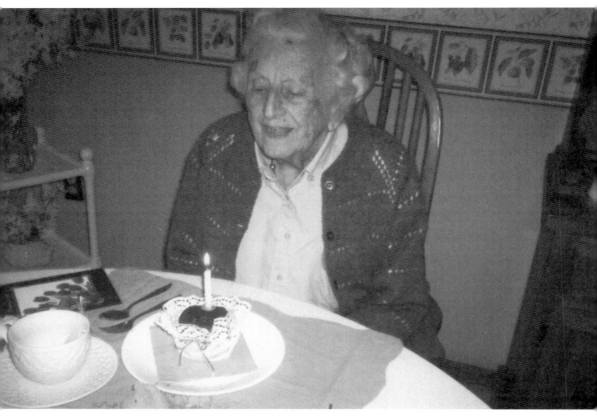

Carrolyn Law

Pelham experienced tremendous growth after World War II. The population doubled in the 1950s and doubled again in the 1960s. With no zoning laws in effect, residents were very concerned about the growth of the town.

Carrolyn Law stepped into the thick of the growth issue, serving on the planning board for five years. The only woman on the board, she served as secretary, meticulously keeping the records that might be needed for potential lawsuits. Together, the board worked tirelessly to create zoning laws that would preserve the character of Pelham and allow for smarter growth. The year 1973 was a critical one for change in Pelham. Regulations were adopted for apartment houses, recreation, and conservation areas, site reviews, and business and industrial zoning. For the first time, Pelham adopted a comprehensive building code, and the planning department was created.

Beginning in 1974, Law was instrumental in completing the work necessary for Pelham's application for designation as a Bicentennial Community. With the construction of the new public library in 2002, Law also donated the funds to create the Law Reading Room, in honor of her husband.

As a military wife, Law's many skills have served her well over the years. In the time before miniatures could be purchased, she hand-crafted a dollhouse and all of the to-scale furnishings. She has created her own upholstery, and has extensively stenciled the walls of her home and barn. She makes her own blueberry preserves from berries on her property, and until a few years ago, she was still baking the biscuits for the Senior Center's Strawberry Festival.

Fiercely competitive, Law would often gather with friends for board games. Her knack for strategy made her a tough opponent.

"Carrolyn is an exquisite example of community involvement," says one of her close friends. (Courtesy of Annemarie Hargreaves.)

Charlene Takesian

Charlene Takesian was elected in 2012 as a Republican state representative for Pelham. Her goal in seeking office was to gain more representation for the town at the state level. Pelham and Hudson currently share 11 representatives, even though Hudson is twice the size of Pelham. Takesian's husband, Hal Lynde, ran as a Democrat, with each of them vying for one of 11 seats in District 37. She won; he didn't.

Originally from Methuen, Massachusetts, Takesian moved to Pelham in 1977. She has been very involved in the community, serving on the board of adjustment, the Sherburne Hall Committee, the Pelham Community Spirit Group, and as the town treasurer since 1983.

As part of the Sherburne Hall Committee, Takesian and others raised over $50,000 to renovate the space at town hall, which previously served as the gymnasium for the former E.G. Sherburne School. The room had been vacant since the school was transformed into the town's Municipal Center in 2002. It is now used for performances, town meetings, and other community events.

The Pelham Community Spirit Group was formed after the town's 250th Anniversary Celebration in 1996. A group of people who wanted to continue planning events for the town approached the remaining members of the Spirit Group to form a relationship. Since then, Takesian and others have introduced the ever-popular Concerts on the Green, Fourth of July celebration, and other town concerts and events.

In 2009, the Pelham Community Spirit Group hosted the first Southern New Hampshire Festival of Trees at the newly renovated Sherburne Hall. The week-long celebration welcomes in the traditional holiday season with bright lights, music, and decorated Christmas trees.

Wreathes and trees are purchased, and then decorated by area businesses and organizations. Visitors come to Sherburne Hall to admire the trees and buy raffle tickets for a chance to take one home.

The money raised by the Community Spirit Group is used to fund other community events. Currently, a $1,000 Community Spirit Scholarship is available to a Pelham resident attending college. Special grants have also been presented to local organizations, such as the Cub Scouts, Friends of the Library in Pelham, VFW Post No. 10722, and the Senior Center. (Courtesy of Charlene Takesian.)

Pelham Garden Club

More formally known as the Pelham Gardeners Group, the organization formed in 1995. A few people with an interest in the community organized to plant flowers and shrubs in front of the former Pelham Library building. Annemarie Hargreaves, Kathleen Johnson and Brian Hebert were among the founders and initial officers. Over the years, the group has grown to over 50 members. The Pelham Garden Club was recognized in the 2012 Pelham Town Annual Report.

The club's projects include decorating Pelham Common for the Christmas holidays, planting and maintaining the gardens in front of the historical society and under the town hall sign, and the planters in front of the library. In 2012, the group donated the blue spruce tree on the south side of the Pelham Library, turning out for the first tree-lighting ceremony in December of that year. The Garden Club does this with its own funds.

Members with expertise in the plant world were instrumental in selecting and maintaining most of the ornamental trees now growing to maturity in Muldoon Park. The trees were purchased using money from the grants awarded to club members.

Residents of Pelham line up for the very popular annual plant sale, which occurs at the First Congregational Church each spring. The inventory is always sold out well before the scheduled end of the event.

Don't have a large garden of your own? That is ok. Over the years, people have joined the group to learn more about how to make their own homes more beautiful, while others just enjoy plants and flowers.

The group is always considering other projects that would add to the beauty and livability of the town.

William "Spike" Hayes

If you want to know about Pelham, past or present, just ask William Hayes. Known by all as "Spike," Hayes was born and raised in Pelham in one of the town's original houses.

Educated in the District I Schoolhouse, he later graduated from Dartmouth College and University of Virginia School of Law. For years, he was a trial attorney with the Internal Revenue Service in the Boston office, heading up their Criminal Division. He has had a distinguished legal career and was awarded the Albert Gallatin Award, the US Treasury Department's highest career service award.

In addition to serving on many committees and boards in town, Hayes is best known in connection with the Pelham Historical Society. He was one of the co-authors of the town's pictorial history book, *Reflections*, and is the curator of the Hayes-Genoter History and Genealogy On-Line Library. The award-winning online library features materials pertaining to the history and families of Pelham that have been collected by Hayes.

Hayes's knowledge of the town has been critical in piecing together real estate deals to benefit the town. He obtained a $70,000 HUD block grant that allowed Pelham to acquire land for the senior housing on Windham Road. He was also heavily involved in obtaining land and expanding use of Raymond Park for the Boy Scouts.

Most recently, he helped the Conservation Commission acquire the former Lareau (Sunny Side Farm), which will connect the Merriam Cutter Conservation Land to Gumpas Pond. The goal is to create a parkland for all to enjoy.

The Veterans of Foreign Wars honored Hayes with its Historic Preservation Award, and he has served as the grand marshal of the Old Home Day Parade.

Hayes and his wife, Judy, remain active in town affairs. No one knows more about the history and politics of Pelham! (Courtesy of William Hayes.)

Vincent Douglas MacDonald

The best way to solve a problem is with a joke and a "Vinnie-ism," at least according to Vinnie MacDonald.

Quick with a silly joke, MacDonald was very active at St. Patrick Parish. He and fellow parishioner Bill Scanzani wrote witty newsletters as part of their fundraising efforts to eliminate the church debt. Together, they worked with Father Ed Richard to accomplish this task.

Born in Portsmouth, New Hampshire, in 1924, MacDonald served his country in both World War II and Korea. He earned the World War II Victory Medal, the American Theater Medal, and the Good Conduct Medal. MacDonald left high school to serve in the Navy as an electrician's first mate, returning to graduate after the war in 1946.

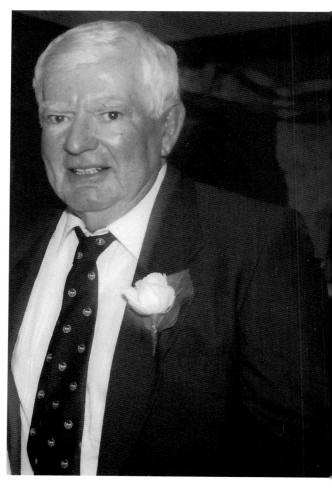

Starting as a lineman, he worked for Bell Systems for over 30 years. He traveled the world, providing his communications expertise for the US State Department and the Federal Aviation Administration. He retired as a senior engineer.

MacDonald was also instrumental in creating the first home for the Pelham Food Pantry. He and other church members constructed the pantry from an old trailer.

But he was most often found out on the golf course or hunting. In fact, he played his last round of golf only eight weeks before his death. "Any day you can spend on this side of the grass is a good day," he would say as he hit the green.

He enjoyed a long life with his wife, Eliette L. "Lee" (Huppe), celebrating 64 years of marriage before he passed in October 2013. (Courtesy of Lee MacDonald.)

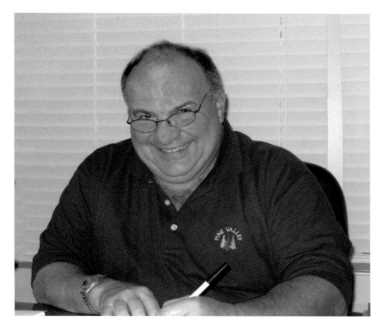

William Scanzani

Love him or not, you always know where you stand with Bill Scanzani. Born in Beverly, Massachusetts, he moved to Pelham in 1976, where he immediately got involved in various town committees and became an active member at St. Patrick Church.

Over the years, Scanzani has become a familiar face around town hall. Serving on the planning board for over 20 years, Scanzani has been charting the growth of Pelham in the past 40 years.

He has attended almost every town meeting, deliberative session, and vote. And he is always informed. With a degree in business administration from the University of Massachusetts at Lowell, and an MBA from Boston University, Scanzani is the "go to" person to ask about contracts and financial issues.

But Scanzani also has an incredible sense of humor, and he enjoys making people laugh, even at his own expense.

During one planning board meeting, Bill was reading many pages of new wetlands regulations into the record. After reading most of the pages, he got a little tired. The phrase "vernal pool," which was repeated frequently throughout the document, came out as "venereal pool." There was a pause, and then everyone in the room erupted in laughter.

Longtime resident and volunteer Eleanor Burton was sitting in the audience. She looked at Bill and in her deadpan manner said, "You couldn't behave for just one meeting, could you."

It took 20 minutes for the laughter to end so that the meeting could be completed. Each time the room quieted, a giggle or snort of laughter would escape, causing the room to be in chaos once again.

After, it was decided that committee members would trade off pages when reading long documents into the official record.

Scanzani's generosity knows no bounds. He has been behind fundraising for St. Patrick Church and was instrumental in helping the parish to pay off its debt and make improvements for worship and fellowship. He worked with Marietta Potter, Father Ed Richard, and Vinnie MacDonald to create a new home for the Pelham Food Pantry when the space grew too small.

He has also been very involved in the Pelham Historical Society, Economic Development Committee, Capital Improvement Project Committee, and countless building and study committees over the years.

Because of his incredible passion for Pelham and its residents, Scanzani has earned the unofficial title of "Mayor." (Courtesy of William Scanzani.)

Marietta Potter

Born in Lowell, Massachusetts, Marietta Potter was a longtime Pelham resident. She was a well-loved and much regarded children's librarian at the Pelham Public Library for many years. She also served as librarian at St. Patrick School and ran a babysitting class for teens at the library.

During her time at the library, Potter saw children visiting on a daily basis and staying until the library closed at night. These children didn't bring snacks, and Potter realized that their only meal each day was the free lunch provided at school. As a result, she started the Pelham Food Pantry in 1991.

Her first task was to convince the town of the need. Potter soon proved that there were plenty of people in Pelham that required assistance. She located space for the pantry and found volunteers to help. For years, the pantry was located in an unheated trailer next to St. Patrick Church. Potter even made house calls to elderly and others who could not get to the pantry. Nothing would stop her from helping those in need.

Potter also used the power of the Internet to bring the food pantry into a network of other pantries. Together, they were able to coordinate efforts to help the most people in the region.

For her dedication to volunteerism, Potter was chosen as grand marshal for Pelham's Old Home Day Parade. In 2011, the town dedicated its annual report to her.

But not everyone always appreciated Potter's work. Famous for her pancakes, one morning Potter promised her grandson Nicholas she would make him breakfast when she returned from the pantry. Soon after, the phone rang; an ambulance had been called to the pantry. Potter had fallen off a folding chair while stacking shelves. When Potter's husband told Nicolas, his reaction was, "Well Grandpa I guess we won't have pancakes today."

Potter passed on May 1, 2014. Her legacy lives on, and continues to serve those in need. Now in a more permanent location, the pantry is privately funded and provides food for over 80 families in Pelham. (Courtesy of Annette Jeanson.)

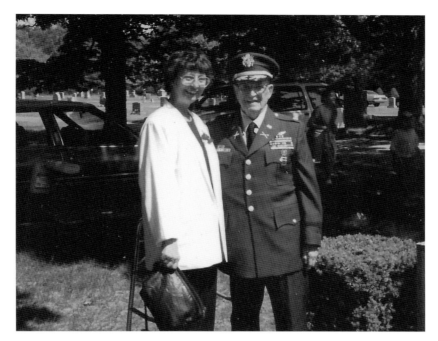

Annemarie "Anne" Hargreaves

When a problem arises, people say, "Someone ought to do something about that." Anne Hargreaves decided that someone might as well be her.

Born in Germany, she was married to military man of three wars, John Hargreaves. Between missions, her husband took her to visit New England, and she fell in love with the area. Following John's retirement, the couple ultimately settled into Pelham in 1971.

Over the years, Hargreaves has become immersed in the community, studying the issues and getting involved. When she learned about the Nashua Regional Planning Commission, she pushed for the town to join. From 1988 to 1996, she served as the Pelham Commissioner to the NRPC.

During this time, she realized the government was providing funds to preserve transportation related programs. Hargreaves had her eye on restoration of the Abbott Bridge, the roadway that connects Route 38 to the Town Center. It is New Hampshire's only double-arched stone bridge. She approached the board of selectmen and received approval to apply for a grant. In 1994, Pelham's project was the only one of 47 applications approved.

Over the next few years, Hargreaves conducted historical research and worked closely with the architects to ensure the authenticity of the bridge. The official "project sponsor," she attended meetings with the selectmen and the department of transportation, and worked with state architectural historical James Garvin to make sure everything went smoothly.

The project was completed in 1998. In 1999, the Town of Pelham received the New Hampshire Preservation Alliance award for the restoration of the bridge. In 2011, Hargreaves personally received an award from the Alliance for one of the 25 greatest preservation achievements in the group's 25-year history.

Hargreaves was also one of the founding members of the Pelham Garden Club, served as a member of the historical society, and has been a part of numerous committees dedicated to studying town issues.

Her daughter, Diane, praises her mom's efforts over the years: "She has been a wonderful role model, especially in her curiosity to continue learning, her social conscience, the love of the arts and books and music and poetry."

"I have never regretted the time I spent," says Hargreaves. She is delighted to have had the opportunity to make her adopted home a better community. (Courtesy of Anne Hargreaves.)

Donna Clark—ARNNE

For most business owners, running one business is enough. Before 2001, Donna Clark already had two businesses in Pelham—Beaver Valley Farm and Pelham Saddlery.

But she as she drove down Route 38 every day, she saw a German Shepherd dog tied to a car bumper, no matter the weather. She was able to take action and the dog was moved to a better location. However, it prompted her to step-up her animal rescue efforts.

In 2001, Clark founded ARNNE—the Animal Rescue Network of New England. The Pelham-based organization is a nonprofit group that rescues various animals and brings them to safer surroundings, and hopefully, new forever homes.

ARNNE regularly sets up at the First Congregational Church to offer animal lovers the opportunity to foster or adopt one of the many friendly dogs available.

Over time, the group has expanded its mission. Initially, in some shelters they had too many cats and dogs, while in others, there were few animals available for adoption. Clark worked locally to coordinate with New England rescues and shelters to provide more animals the opportunity to find their forever home. The group now brings animals from states with high-kill shelters, especially those in the south, to New England.

There is no full-time paid staff; everyone is a volunteer. Fundraising is constant. The costs for transporting animals from other parts of the country, veterinary care, and emergency surgeries add up quickly. Local schoolchildren help out by selling Bow-Wow Biscuits, dog treats they make and package themselves. There are raffles, donations, pet photographs, and other events, all designed to bring in the money needed to care for the animals.

"It's a constant challenge, but once you've had the experience of an animal rescue you just can't turn away," says Clark.

Ellen Schofield

The former owner of Pet Styles, Ellen Schofield worked with Pelham-based ARNNE, the Animal Rescue Network of New England. As a groomer, her biggest gift was getting the homeless dogs ready to meet their prospective families. A "tubby," haircut, and nail trim could make all the difference in the world to a four-legged friend. Removing the matted fur and getting the dogs smelling clean set them up for looking and feeling their best.

Starting with grooming horses, Schofield was asked by friends if she could also groom their dogs. She was working at a gym at the time, and when she tore her rotator cuff, she realized it was time for a change.

She got to know Donna Clark, owner of Beaver Valley Farm in town. When Clark founded ARNNE, Schofield immediately got involved. She began by offering to bathe and groom the dogs. Because of her business, she also knew lots of wonderful people who had room in their hearts for new family member. Soon, she was going to adoption days, fostering and transporting dogs, and actively placing them with families.

For over 12 years, Schofield worked as "groomer to the stars." Looking through her stacks of photographs, she can name each dog, and tell a story about how it found its forever home.

According to some shelter policies, dogs are put to sleep rather than offered for adoption because of their age. Schofield has walked into rescue situations and saved many older dogs from needlessly being put down. Puppies have found their way into homes and senior dogs have adopted new families, thanks to the efforts of Schofield and the team in which she is involved.

Moving to Florida has not stopped her rescue activities. She has a new grooming business and remains involved with the local animal groups. To the delight of many, Schofield is often seen visiting nursing homes and rehabilitation facilities with miniature horses. (Courtesy of Ellen Schofield.)

Cathy Pinette

Who is ever ready for the unexpected? Although many cities and towns have groups to handle emergencies, they generally rely on the services of trained personnel. But even those emergency service providers need basic information to give effective assistance.

In May 2006, Pelham experienced the Mother's Day Flood. The heavy rains caused the overflow of the banks of Beaver Brook, leaving several of the bridges in town completely under water. Roads were closed to traffic and residents were essentially trapped on their side of town, with many unable to access certain town services.

In a town like Pelham, with annual flooding, snowstorms, fires, power outages, and a variety of wildlife, it is important for residents to be prepared for various situations.

It was this concern that led Cathy Pinette to take action. In 2009, she collaborated with Bill Scanzani and Daryle Hillsgrove to form the Pelham Community Awareness and Preparedness Organization (CAP).

Under the motto "Neighbors Helping Neighbors Create Disaster-Resistant Communities," the organization's objective was to educate and inform citizens in the community about the challenges of disaster preparedness and, more importantly, to help them plan for a community-wide response in the event that such a disaster occurred.

A nonprofit organization, Pinette, and others offered free classes to residents, including Essential Supplies for a Prolonged Stay in Your Home and Basic First Aid and Home Emergencies. Handouts were provided to those who could not attend classes. Pinette put together information packets that were distributed through the local businesses. With assistance from Hillsgrove and Scanzani, she maintained the information on the CAP website.

Although the group dissolved in 2009, Pinette has the satisfaction of knowing that over 1,600 members of the community received potentially life-saving information. (Courtesy of Cathy Pinette.)

CHAPTER SEVEN

Family Farms to Family Business

In a world of chain stores and large franchises, New England has long been a hold out, maintaining opportunities for the traditional family businesses.

In the mid-1800s, John Woodbury ran the first store in the Town Center. His son Frank took over the family business in 1876. But the best known business of its time was Atwood's Store, which housed the general store, the post office, and, in later years, the gas station.

Pelham was also a thriving tourist destination, with several inns dotting the many lakes and ponds in the area. The trolley brought people from the hot and dusty cities to enjoy the quiet, tree-lined paths and cool water.

As the large farms in town ceased to operate, the roads were paved. More automobiles brought larger businesses and more traffic to Pelham. The large shopping center along Route 38 replaced Atwood's Store.

Though no longer a resort destination, the town has been home to many family businesses, including a very successful small bank, one of the best-known function facilities in the region, and a unique movie theater.

John Woodbury and Frank Woodbury

Initially a shoemaker and farmer, John Woodbury arrived in Pelham in 1836. He served on the board of selectmen and as the town clerk for many years.

Acquiring property in Pelham Center in 1843, Woodbury began operating a store and the local post office from his house. He acquired several lots in the Town Center before handing over his businesses to his son Frank in 1876.

Frank moved the store and post office to the immediate west of the First Congregational Church. In 1905, he sold the property to Harry H. Atwood, who continued to manage it as a general store and post office.

In 1896, Woodbury donated land for a new Library and Memorial Building to be constructed in the Town Center. A year later, he deeded land to General Stark Colony No. 30, United Order of Pilgrim Fathers to construct Pilgrim Hall. After a fire destroyed the old town hall in 1906, the town finally approved the purchase of Pilgrim Hall for use as a town hall in March 1917.

Harris Hibbard "Harry" Atwood

Born in Pelham in 1877, Harry Atwood married Carrie Stickney in 1899. Their union produced 15 children, 10 of whom lived.

Atwood served as the town clerk for 12 years, and postmaster for 42 years, appointed by Theodore Roosevelt in 1905. He was also agent and operator of the Pelham Telephone Association.

He is best known for his store in the Town Center. Atwood's General Store was the place to get everything, including information. The store housed the post office, and gas pumps were added in later years to accommodate automobiles. The store was torn down in 1966 after the plaza and new post office were constructed on Bridge Street.

To accommodate Pelham's summer guests and to promote tourism, Atwood hired photographers and produced penny postcards that displayed Pelham's historic buildings and beautiful surroundings.

Atwood and his family may have had a guardian angel watching over them. On three occasions, fires at the First Congregational Church and surrounding buildings threatened to destroy the Atwood home. In 1910, the church and horse sheds were struck by lightening. In 1921, a garage was destroyed by fire. Years later, fire ripped through the lines of horse sheds. Fortunately, the men at the Pelham Car Barn discovered the fire and spread the alarm. They dragged a hose from the car barn water tank and saved the day. Volunteer fire fighters also showed up with the "time-honored bucket brigade" to render assistance.

Atwood's dedication to historical research is phenomenal. In 1946, he and Mary Sherburne wrote a very complete history of the early days of Pelham for the town's 200th Anniversary Celebration. (Courtesy of Pelham Historical Society.)

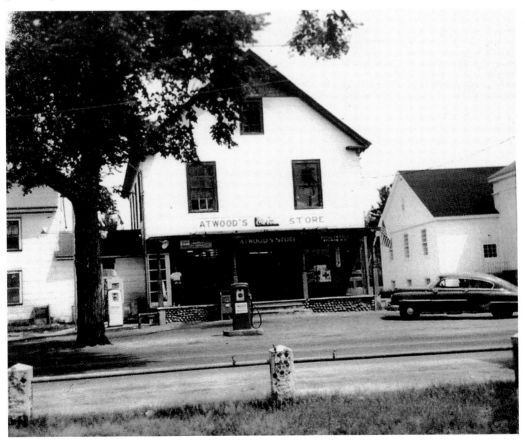

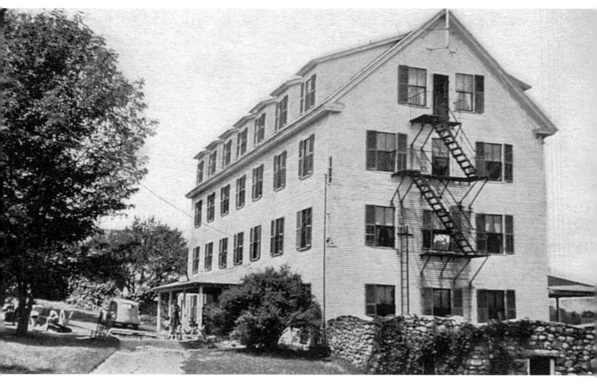

Harry and George Harris

Chances are good that most Pelham residents have enjoyed a wedding, prom, awards dinner, reunion, or other party at Harris' Pelham Inn.

"The strength of our business is all about family." This was a 2006 statement from fourth-generation property owner and Harris Pelham Inn proprietor George W. Harris Jr.

Around 1900, Harry A. Harris and his brother George C. Harris purchased 37 acres of farmland in Pelham to build a summer resort. In 1906, the Harris family opened the Grand View House on the south side of White Pond (later renamed Harris Pond). The House was a four-story inn featuring 38 guest rooms for up to 50 guests, chambermaids, bellhops, and a large dining room.

The Grand View House advertised all the latest conveniences, such as modern plumbing and electricity. Drivers were available to take guests to and from the electric cars that stopped at Pelham Center. By 1909, the Inn even featured telephone service. Room rates were $7 and $10 per person, per week, which included three meals a day. The inn became well known for its outstanding cuisine, all fresh from its own farm.

In 1918, the name was changed to Harris' Pelham Inn. With several functions held there during the course of a year, it quickly became known as the place to hold special events. In 1961, the Inn stopped operating as a summer resort. With the arrival and motels and camping, the business for resort stays had diminished. The Inn was converted to function rooms in 1962, and larger rooms were added upstairs.

The Inn continued to gain popularity. In the 1970s, they even hosted George Romney, father of former governor Mitt Romney, who was attending a fundraiser there.

Today, the Inn is still one of the most popular places to hold an event, and everyone is treated like family. (Courtesy of Pelham Historical Society.)

George W. Harris Jr.

George W. Harris Jr. was born in Pelham in 1928. Educated in the Pelham and Methuen school systems, Harris attend the University of New Hampshire and then served in the 89th Fighter Squadron of the US Air Force. In 1953, he married Betsy C. Herrick, with whom he had five children. He passed away on September 3, 2012.

Harris was best known as the owner of Harris' Pelham Inn. The fourth generation to run the century-old inn, he took over with his mother after his father passed away in 1965. His mother retired in 1969.

Active in the community, Harris was director of Granite State Electric Company, vice president and cofounder of the Pelham Bank and Trust, a partner in the Southern New Hampshire Industrial Association, and a member of the New England Businessmen's Association.

Harris was also a generous benefactor of the Pelham Food Pantry and Good Neighbor Fund, local churches, and Pelham's 250th Anniversary Celebration.

In 1998, the Town of Pelham dedicated the Annual Town Report to Harris. In September 2006, Harris was recognized by the Greater Salem Chamber of Commerce as the William A. Brown Businessman of the Year. The award is the Greater Salem Chamber of Commerce's highest honor.

Harris was responsible for the Harris Family Track and Field Complex, completed in 2003. He could always be found at the field cheering on the home team at football games and track events. He was always supportive of the student athletes, and despite a busy banquet schedule, in March 2009 he left a Friday night open to honor the Pelham Python football players and their coaches and family for their second straight Division V championship and another perfect 11–0 season.

A Republican known for his love of political banter, Harris knew exactly how to get someone riled up. His favorite target was Philip "Bud" McColgan, a Democrat. Harris would make a few statements to get him started, and then step back with a devilish smile on his face as McColgan provided the desired reaction.

Harris often acknowledged, "There is always a great temptation to sell," but, "there is a certain amount of pride in holding on to a family business. It is not always about the money." (Courtesy of Pelham Historical Society.)

Carl Hirch

Born in October 1902 to Ludwig and Caroline Hirsch, Carl Hirsch grew up in Pelham. Working the farm at the top of Jeremy Hill, Hirsch had an egg route and later delivered milk locally.

In 1924, he married Malvena Ross and eventually purchased the Lucky Acres Farm on Mammoth Road. They had two children, Robert and Josephine. Hirsch continued his milk route, expanding his deliveries into Lowell, Massachusetts, but discontinued it in 1946.

With the end of World War II, the building boom was beginning. He and his brother Albert founded the successful Hirsch Brothers Construction.

In July 1951, he and Albert took off in a converted Army training plane heading to a site where they were to begin work. Albert was flying when the plane crashed crash on Blye Mountain in Newbury, New Hampshire. Albert was able to walk away with few injuries, but Carl suffered severe head trauma and was unconscious for days. Despite two operations, Carl passed almost a week later. (Both, courtesy of the Hirsch family.)

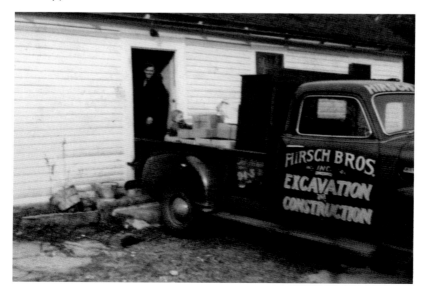

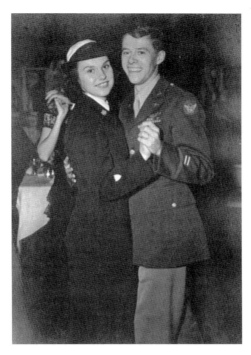

Paul Jr. and Mary Lou Fisher

When Paul Jr. and Mary Lou Fisher moved to Pelham in 1955, they chose what was known as the Seavey Mill homestead on Gumpas Hill Road. Born in Bronx, New York, Paul Jr. had served in World War II, flying a P-38 in the European Mission. Mary Lou hailed from Chicago and served during the war in the Coast Guard.

The Fisher farmhouse is one of the oldest in town and once served as a tavern for travelers going from Lowell, Massachusetts, to Nashua, New Hampshire. Travelers would come up Gumpas Hill Road (named after a man called Gum; it was referred to as Gum's Pass) to stop for the night before continuing through Hudson. After a bit, the tavern became the home for the Seavey Mill, a working lumber mill. The stonework for the mill still remains.

Over time, the Fishers cut down the trees in an old apple orchard and removed the stumps. In the process, they discovered the field was a wonderful gravel deposit. Paul and Chet Spaulding Jr. started Hillsboro Sand and Gravel Company.

The gravel pulled from the land was used locally in Pelham, including in the bridges on Willow Street and Windham Road, and in the construction of the Memorial School. As the gravel was removed, springs were exposed and the Fishers ended up with a beautiful spring-fed pond.

During this time, Mary Lou worked for EFNEP (Expanded Food and Nutrition) for the University of New Hampshire, helping low income families learn about healthy diets. When Paul retired, he began growing hothouse cucumbers. This was the start of Fisher Farm, as Paul and Mary Lou believed people needed access to farm fresh food.

With three 50-foot-long greenhouses, the Fishers grew hothouse tomatoes, flowers, vegetable plants, and their famous Patio tomatoes. The children helped, plowing and growing their popular Burgundy corn. Paul delivered tomatoes, plants, and flowers to local stores. The family worked the first farmers' market in Lowell, Massachusetts, for many years and had a farm stand from 1980 to 1998.

Paul Jr. passed in April 1997 and Mary Lou in August 1998. They left two 16-acre tracts of land at the end of Gumpus Hill Road to the Society for the Protection of New Hampshire Forests as co-owners with family members. They hoped people would enjoy the beauty of the forest that they called home for 43 years. (Courtesy of the Fisher family.)

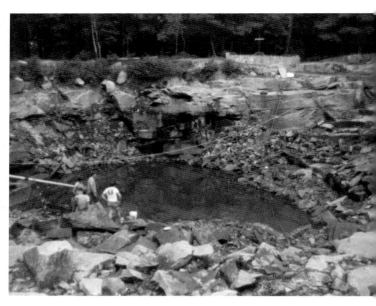

Arthur Bedard

New Hampshire is known for its granite. Stone from Pelham's quarries was used to build many of the area's familiar buildings and structures.

Arthur Bedard earned his living at the quarries on Gage Hill Road in Pelham. Owned by Edward Searles and the Woodman family, granite stone was taken from the quarries to build the walls at Searles Castle in Windham, New Hampshire, and Methuen, Massachusetts. The stone was also used to construct Our Lady of Mount Carmel Church in Methuen and part of the Pawtucket Dam in Lowell, Massachusetts.

Bedard was born in Canada in 1892 to William, a stonemason, and his wife, Delia. The family traveled to find work, eventually settling in Lawrence, Massachusetts. At an early age, Bedard was working before and after school. By age 12, he was driving a horse and wagon to sell milk and butter. About that time, he came across several acres for sale on Gage Hill for $50. Borrowing the money from his employer, he bought the property on what is now Bedard Avenue.

In 1922, he married Georgiana Rondeau of Lawrence. They left the comforts of their Lawrence home to move to his land in Pelham, which had no electricity or indoor plumbing until much later. Together, Bedard and Georgiana raised 17 children.

Over the years, Bedard worked at the quarries. The quarrying of granite involved using dynamite or a black powder to blast the ledges. It left a mess, shooting boulders several hundred yards. One day, Bedard came home to find big holes in one of the windows and walls of his house. Searles arrived, offering to buy the Bedard home so that he would not run the risk of being sued every time they blasted in the quarry. Bedard refused.

Eventually, the quarries became unworkable. Water from the underground springs filled the holes created by removing the rock, and could not be drained. The Bedard family found other uses for the quarry. Summers found the children bathing at "the Ledge," as they called it, taking turns diving off boards they built. During the colder months, ice skating was popular.

A practical, hardworking man, Bedard enjoyed his grandchildren and great-grandchildren. The family stayed close, gathering regularly for holidays, weddings, and other celebrations. (Both, courtesy of Jackie Blanchette.)

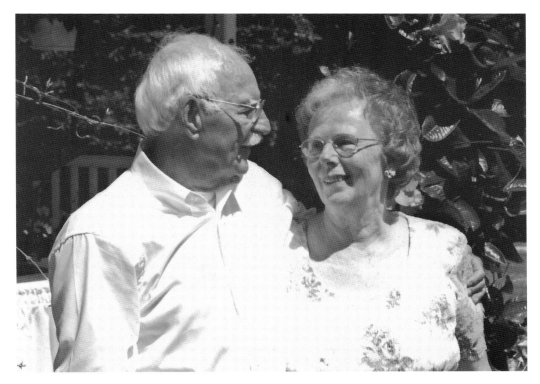

Charlotte Moore

A resident of Pelham for almost 65 years, Charlotte Moore is constantly in action. She has served on various boards and committees, including supervisor of the checklist, the budget committee, Council on Aging, Pelham Library Board of Trustees, Firefighter's Auxiliary, Firefighter's Association, and board of selectmen. She was a very active member of Pelham's 250th Anniversary Celebration.

Older residents remember that Charlotte and her first husband, Duke Vautier, ran the Pelham Transport Service. From 1959 until 1976, the couple ran a bus company, with a regular route that took passengers all over Pelham, into Lowell and Dracut, Massachusetts, and throughout southern New Hampshire, including Salem, Hudson, and Nashua.

In the 1950s, Pelham did not have its own high school. Students were sent to other towns to attend classes, but were required to find their own transportation. Pelham Transport was born when the couple realized they needed to transport their own children to school.

The couple ran school bus services in Hudson and Wilton, New Hampshire, for many years. But they also did a lot of charter work. Charlotte recalls a group of students she and Duke brought to Fenway Park in Boston. The busses were parked perpendicular to each other. She was sitting on her husband's bus and noticed a group of kids that were not her charter group on her bus. As she boarded her bus, she heard water running which was odd as the bus had no facilities. She realized that the kids had been smoking marijuana and were urinating, and she called the police. She also made the kids clean up their mess.

Duke Vautier passed away in 1999. Charlotte met Richard Moore (pictured above) through an online dating service, and they were married in July 2001. Though in their 80s, the couple is active in the sport of geocaching, a real-world, outdoor treasure-hunting game using GPS-enabled devices. Participants navigate to a specific location and then look for the geocache hidden there. Richard's son in Wisconsin got them started, and it has become a family affair. In fact, Moore put together a very special cache dedicated to John Hargreaves, who was very active in veterans' affairs in town. (Courtesy of Charlotte Moore.)

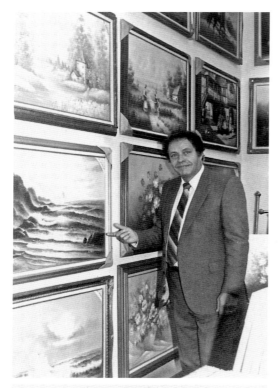

Alrick and Rick Hammar

In a time when people valued fine craftsmanship, business signs were created by hand. With a natural artistic talent, Alrick Hammar was hand-painting signs for local retailers at a young age. Eventually, he rented a small shop on Pearl Street in Lowell, Massachusetts. With his wife, Mary (Milinazzo), Hammar Signs sold to local chain department stores and supermarkets, such as Demoulas, Alexanders, Claremont Market, and Rich's Department Stores.

Al had a unique style of lettering, and the word spread about his quality work. The product line grew to include plastic, vehicle lettering, and hard-carved wooden signs. When they outgrew the space on Pearl Street, Al and Mary added on to their home on Hobbs Road in Pelham to accommodate the business and the growing family of five children.

Rick Hammar was destined to take over the family sign-making business. At the age of nine, he was already hand-painting signs in the garage after school. He had to stand on cinder blocks to reach. Soon after, brother Michael joined him.

The business had a large demand for political signs. The family invested in silk-screen printing equipment and began mass production of paper signs. The business grew so much that Hammar became known as the "Political Sign Guru." (Both, courtesy of the Hammar family.)

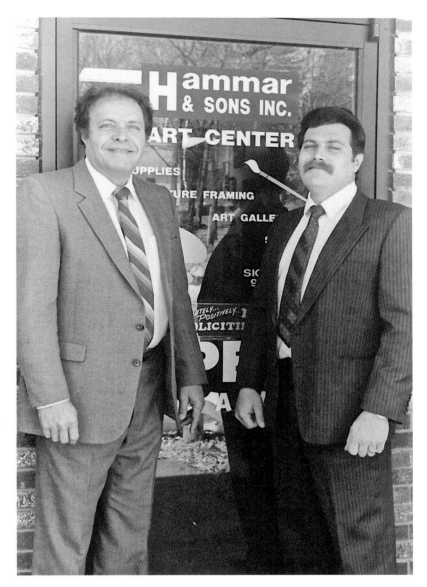

Hammar & Sons

In 1976, Rick and his wife, Brenda (Howe), expanded the family business again, this time to include art and picture framing. The couple opened an art studio and picture frame shop on the corner of Main Street and Broadway in Salem, New Hampshire. Brenda waited on customers and sold art supplies while Rick did custom framing in the back. On weekends, the art studio offered oil painting classes with local artists. There would be up to 50 students enrolled in a class on any given afternoon.

The sign business and the art studio continued to grow. Rick's father, Alrick, purchased a building along Bridge Street in Pelham to house the two businesses, and the name was changed to Hammar & Sons, Inc. Over the years, the building would require two expansions to accommodate new sign-manufacturing equipment.

Even as the business grew, the family found time to give back to the community. Al and Rick have served on various committees, and Al was on the board of selectmen. (Courtesy of the Hammar family.)

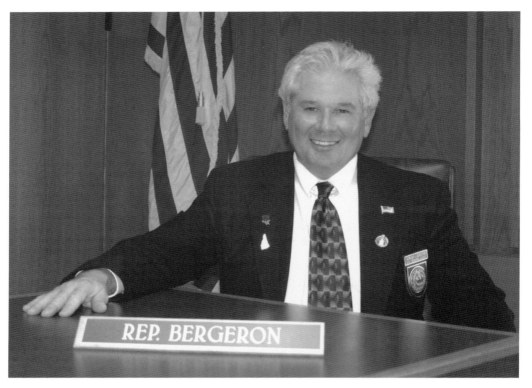

Jean-Guy Bergeron

Originally from Lowell, Massachusetts, Jean-Guy Bergeron has one of the longest-running businesses in Pelham. In 1969, Bergeron leased the former Enoch Marsh estate in town for his automobile parts and repair business. By 1973, he owned the property and has operated a successful business for the past 45 years.

Bergeron has served as town selectman, and from 2001 to 2008 as a state legislator. On the transportation committee, he was a strong supporter of child safety laws. (Courtesy of Jean-Guy Bergeron.)

Lorraine Bedard Bergeron

"Avon Calling!" Known by all as the "Avon Lady" for over 50 years, Lorraine Bergeron won recognition and awards for her work selling the popular skincare products. Born in 1919, Bergeron was one of 17 children of the Bedard family.

A talented seamstress, Bergeron took care to make sure she always looked her best. When she was younger, she would save part of her paycheck to purchase something new. (Courtesy of Jackie Blanchette.)

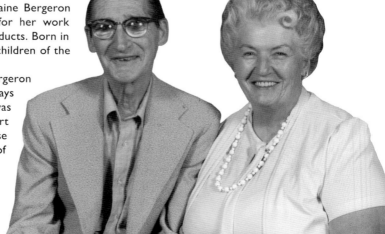

James Nagel

Jim Nagel, one of the owners of Chunky's Cinema Restaurant, offers patrons dinner and a movie in one place.

The theater features a full-service restaurant with a Hollywood-themed pub menu, adult beverages, fun desserts, and no uncomfortable chairs. Everyone sits in a cushy seat taken from a Lincoln Continental at a communal dining table. The seats roll and recline, allowing guests to relax and enjoy. The theater gets first-run movies and the parking lot is always full during show times.

Looking to go into business for himself, Nagel initially purchased a one-screen theater in Plaistow, New Hampshire. He quickly brought it to a whole new level. When the flea market building in Pelham became available, he opened a two-screen theater, expanding it to the current five screens within one year. In the past few years, the business added another large complex in Nashua, New Hampshire.

Chunky's in Pelham opened its doors in 1997. The blockbuster film *Titanic* was just opening, and Nagel watched the crowds line up outside the door for hours to see the movie. "One girl spent two hours waiting to see a three-hour movie, and then after it was over, got in line to see it again. It was amazing!" The film ran for over five months.

The chain has since included special showings of older films, sporting events, and season finales of popular television shows. Comedy and piano shows are also being added. And yes, there are *Rocky Horror Picture Show* events.

Community involvement is important to Nagel. Chunky's gift packs are often part of local raffle prizes. Because the theater/restaurant employs many students from Pelham High School, Nagel tries to support them as much as possible. Nagel also hosts an election night party every year after town meeting. The gathering offers residents to come together hear results and "kiss or cry," depending on the outcome.

The best part of his job? Watching the constant flow of movies every week. (Courtesy of Jim Nagel.)

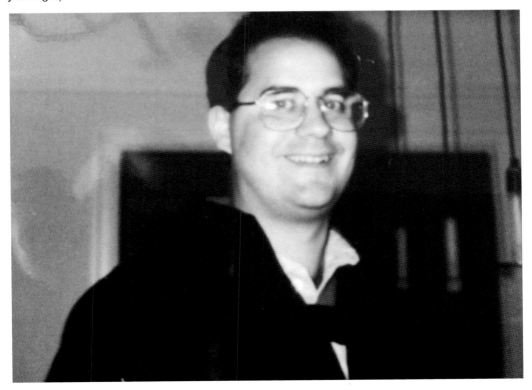

Pattie Boutwell Perkins

A former Naval Reserve officer, Patricia "Pattie" Perkins knew about the American flag and what it meant to her. "The flag means home," she wrote. In 2001, she submitted her essay to Freedoms Foundation at Valley Forge. Shortly after September 11, 2001, she learned that her essay, "Flag Day Speech," had received the highest honor bestowed by the group.

Pattie grew up in Pelham as the daughter of Nate "Smokey" Boutwell. (Courtesy of Patricia Perkins.)

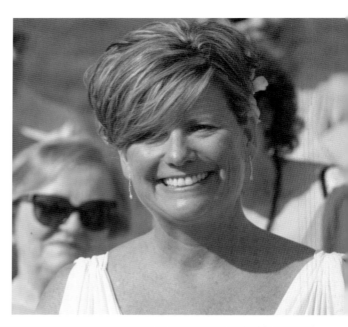

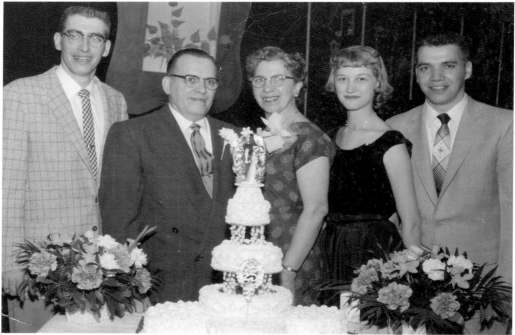

William Greenwood

Pelham homes built from the late 1960s through the 1980s probably feature custom-made cabinets made by Pelham Woodworking. Billy Greenwood started the business that is along Bridge Street, employing members of his family. He used real wood to construct his built-to-order cabinets. Greenwood is pictured on the far left in the photograph from the anniversary party for James and Dorothy Greenwood. (Courtesy of Jim Greenwood.)

CHAPTER EIGHT

The Town's
Talented Artists

Life is not all about work. There is time for developing and sharing hobbies, skills and talents. Pelham has always been home to some incredibly talented people young and old. These include sculptors, writers, painters, singers, craftsmen, and performers. People in neighboring towns have visited Pelham to experience some of the town's cultural presentations.

Mary "Aunt Molly" Hobbs

It seems that everyone knew Mary Hobbs as "Aunt Molly," the town's first librarian who held that position for more than 50 years. She was solely responsible for growing and managing the town's collection for years. The Pelham Library building was constructed in 1896 and served that function until 2003.

Hobbs would go to Boston on a regular basis to acquire materials for the library. She was given freedom to select books of her choosing based on what she thought the collection should include.

The library was open only a few hours a week, but Hobbs made sure to open the doors after Sunday church services to allow for library visits.

Hobbs was fond of children, and began a regularly scheduled time where she would read to them. Later on, the library created a children's room in the basement of the building. However, the space was never big enough to accommodate the growing number of young patrons who wanted their regular visits with "Aunt Molly."

When the new library opened in 2002, space for story time was limited. However, under director Sue Hoadley, trustees created a larger space for children's programming and meeting space. The room was named the "Molly Hobbs Room," in honor of her years of service to the town and the library.

Hobbs was also an amateur photographer. While a teenager, she became fascinated with photography and owned her own glass plate camera, tripod, and the equipment for developing the glass plate negatives and printing paper photographs.

Between 1896 and 1920, she took many photographs, most of the plates for which were passed down to C. Frances Hobbs, known as Aunt Kina. The plates were left to Charlie Hobbs, friend to Burt and Joyce Mason, and have since been donated to the Pelham Historical Society, the original library building where Hobbs spent her career. (Courtesy of Philip Currier.)

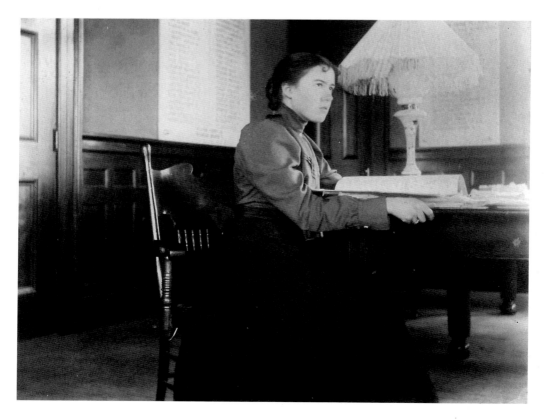

Mary "May" Sherburne

Mary "May" Semple Hillman was born in 1888 as the daughter of Frank Hillman and Alice Greeley. She studied to be a teacher, and taught at the Gumpus School in 1911. However, she contracted typhoid fever, which ended her teaching career early.

She told the story that during her recovery, Ernest Sherburne would try to console her, and she "ended up here on the hill." Earnest and May were married in 1914.

During her life, May was very involved in community activities. She was program director for the Pelham Grange, head of the women's auxiliary for the Farm Bureau Organization, a 4-H leader, clerk of the First Congregational Church, and a trustee for the Pelham Public Library. She even served as a library assistant to Aunt Molly Hobbs from 1892 to 1955.

However, May was best known for her artistic abilities. At age 12, she created a pen-and-ink drawing of Pelham that accurately depicted every street, home, farm, and public building. She also worked in oils and water color paints, completing her works on paper and canvas. Over 125 works were either sold or given to friends.

Later on, May taught art at the Sherburne School, even continuing past retirement age. She also taught classes at her home in the evenings and on Saturday mornings.

In 1946, May worked with Harry Atwood to prepare a history of Pelham for the 200th Anniversary Celebration. Sherburne's section was titled "Tales of Old Pelham," which recalls stories of amusing or notable incidents and people from Pelham's early days.

May Sherburne passed away at 90 years old on May 10, 1975. Some of her artwork is on display in the Ruth Sherburne Sturrus Art Gallery through the Pelham Historical Society. (Courtesy of Philip Currier.)

David Alonzo Greeley and the Greeley Singers

From 1886 to 1906, the Pelham Sing concerts were popular in town. Born in Pelham, David Alonzo Greeley's passion was music. He was a music teacher, organist, and choir director. He offered the Congregational Church a deal - if they would purchase an organ, he would play for free every Sunday for the rest of his life. The organ was installed, and for 40 years, Greeley played weekly.

Pelham Sing concerts were held at the town hall and the church. Once a year, the singers would come, rehearse all morning, and then enjoy a dinner prepared by the townspeople. The concert followed in the afternoon. Greeley's last show was in 1908. He died a year later of bronchitis.

A revival of Pelham Sing was held for First Congregational Church's 200th anniversary in 1951. It was so well received, that another concert was given at the Pelham Memorial School in 1996 for the Pelham 250th Anniversary Celebration.

Even after the anniversary celebrations passed, the group decided they really enjoyed singing together. Thus, they reformed as the New Greeley Singers, which performs a wide variety of music. The concerts are just as popular as ever. (Left, courtesy of Philip Currier.)

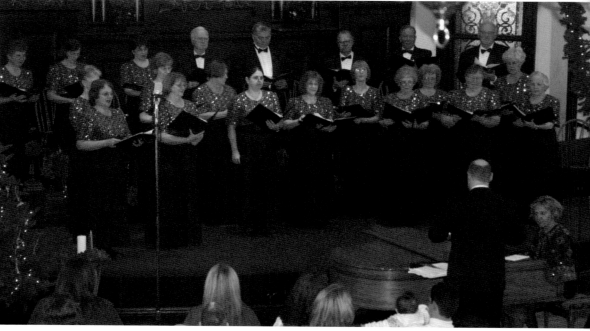

Jillian Fisher

In June 2013, celebrities such as Sarah Jessica Parker and Usher admired art projects on display at Carnegie Hall. One was created by Pelham's Jillian Fisher.

Fisher had dabbled with ceramics as a child, working with a battery-operated potter's wheel. But she had only been working seriously for a year when her teacher submitted her work for a competition. In 2013, her piece *Lidded-jar Set* was selected for the New Hampshire Art Educators' Association's Vision Award and judged best in category.

Fisher was one of 13 New Hampshire students—and three Pelham High School students—receiving national honors and chosen to have work displayed at the National Scholastic Awards Show at Carnegie Hall in New York.

Fisher plans to attend Nashua Community College to obtain a business degree, and then move to Savannah, Georgia, to get a degree in interior design. (Both, courtesy of Jillian Fisher.)

 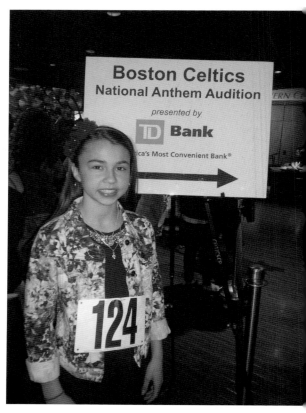

Nicole Pelletier

With the voice of an experienced singer, Nicole Pelletier was recently chosen to sing the National Anthem for the Lowell Spinners, the New England Revolution, and the New England Patriots. She was also chosen to sing at a Boston Celtics game. The most amazing part is that Nicole is only 11 years old.

Nicole began singing in third grade when she learned the National Anthem at school. Her parents were impressed with her ability, and encouraged voice lessons. Nicole said no as she already knew how to sing. But in 2013, she did agree to a voice coach.

The family is currently seeking an agent for Nicole. Her desire is to be a singer and actress. Perhaps she will audition for the television singing competition show *The Voice* or wind up on the Disney Channel. There is no holding her back! (Both, courtesy of Pelletier family.)

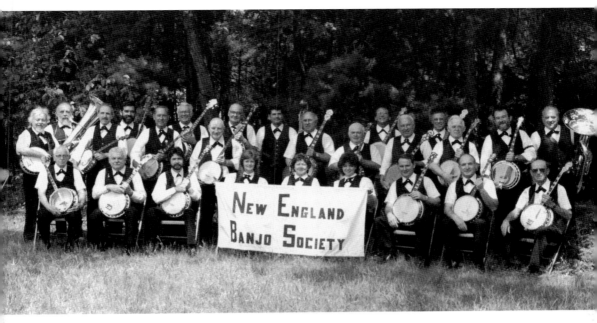

The Yankee Strummers

Formed in the early 1980s, the Yankee Strummers of the New England Banjo Society had the honor of playing for Pres. George H.W. Bush twice.

The New England Banjo Society is a nonprofit organization dedicated to preserving and promoting the banjo, the United States' only native instrument.

Glennie Edwards remember playing for President Bush. "It was quite a thrill to know your president was sitting down in the audience." After the concert, the president came to meet the members of the band.

Deciding to learn something new, Edwards had taken up the banjo around 1980. She would eventually form the Yankee Strummers and take them on the road to perform.

The Yankee Strummers were invited to play in concerts, fundraisers, and other events. Their venues ranged from the Hatch Shell and Faneuil Hall in Boston, Massachusetts, to the halls of the local Veterans of Foreign Wars.

Pelham resident Edward Dubreuil, co-owner of the former Banjo Pub in Tyngsborough, Massachusetts, was a member of the group. Playing the banjo was his true love and he did it for over 21 years at Canobie Lake Park in Salem, New Hampshire, as well as with the Yankee Strummers

Sharing banjo lore and showcasing their musical abilities, the Yankee Strummers would have toes tapping to familiar tunes ranging from marches to popular ballads. The group would usually include 20–30 banjoists, often accompanied by piano, tubas, and bass.

In 1985, the Pelham-based group was featured on several television shows, including two half-hour specials, and at the Tall Ships celebration in Kittery, Maine. (Courtesy of Glennie Edwards.)

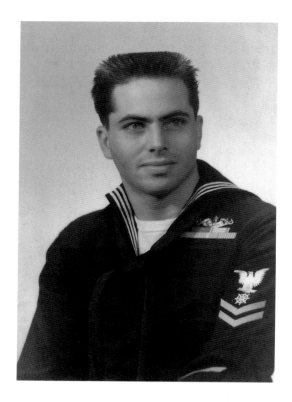

Charles Dick

In the 1940s, Charles Dick was a high school student in Culver City, California. His friend's father had created a chess board, with a variety of inlaid wood. Dick decided he needed to learn the hobby himself.

Born in Los Angeles in 1934, Dick served in the US Navy for 20 years and through two wars, Korea and Vietnam. He made his own chessboard and carried it along with him on the Navy submarines.

In 1962, Dick found himself in Lowell, Massachusetts, working as a recruiter for the Lowell Navy Station. There, he met his wife, Patricia, who was a candy striper at nearby St. John's Hospital.

After retiring from the Navy, Dick was working at a local business-forms company. Unfortunately, that was when he had his first stroke. During his recovery, he decided to pursue his love of carving and inlay work. He began making the plaques as wooden greeting cards for birthdays and special occasions for his grandchildren. Each is outlined with a wood-burning tool and hand-painted with acrylic paints, taking four to six hours to complete.

The master woodcarver has many of his carvings displayed about his home. He does not sell his creations, but enjoys giving them as gifts.

Over time, he had two more strokes, which left him with double vision and some numbness in his left hand. Now, he walks with a cane, but not just any cane. He created one for himself with the carving of the skull on top. Like its creator, the skull is missing a bottom tooth, demonstrating Dick's incredible sense of humor.

"He's tough," says his wife.

His work has been displayed at the Pelham Public Library as part of the Artist of the Month program, which features local artists. He has volunteered his time at with Cub Scouts, demonstrating his carving talents and showing boys how to carve whales from Ivory soap.

From 1992 through 2003, he coached the chess club at Pelham Memorial School. A proud member of the local VFW, and enjoys his regular visits to play cribbage and chess. While he no longer coaches, he is happy to play a game with anyone who will sit down with him. (Courtesy of Charles Dick.)

CHAPTER NINE

Celebrities Among Us

Artist Andy Warhol once said, "In the future, everyone will be world-famous for 15 minutes." A lucky few from Pelham have achieved a national level of notoriety for more than 15 minutes.

Some have sought to be in the public eye, while others followed the opportunities presented. For Megan Lamontagne, baton twirling would lead her center stage, while Nick Groff went from his position behind the camera to being the one filmed. Barbara Walsh had no idea her time spent interviewing hardened criminals would lead to a Pulitzer. Hosting various local television shows has allowed Gail Scott-Key to interview a variety of Hollywood celebrities herself. And the cow? You decide.

The Lamontagne Family

Seven-year-old Meghan Lamontagne desperately wanted a pet. She constantly pestered her parents for a dog, a cat, anything.

For her eighth birthday, parents Patricia and David finally gave in. They loosely wrapped a live kitten in a box and set up the video camera to capture the surprise. When Meghan tore open the paper, she was speechless. Her reaction was a series of "Oh my" and "Is this for real?"

The television show *America's Funniest Home Videos* always asks viewers to send in videos. Patty and David did, and then forgot about it. A few years later, the phone rang. The Lamontagne family had been selected as one of three finalists for *AFHV*, and were flown to Los Angeles. Finally, the moment came where the winner was selected; Meghan's surprised reaction to the kitten won the family $10,000. (Both, courtesy of the Lamontagne family.)

Meghan Lamontagne

Meghan Lamontagne began her baton-twirling career at three years old, joining the Red Star Twirlers in Derry, New Hampshire. Even after moving to Pelham when she was in first grade, she remained with the group. She participated in regional and national competitions with the goal of becoming a majorette at a prestigious university.

In 2005, while a junior at Pelham High School, she competed for the title of Miss New Hampshire Outstanding Teen, a part of the Miss America pageants. Meghan was awarded the title, the very first in New Hampshire and went on to complete in the national contest.

She was accepted at Purdue University in Indiana. The competition among baton twirlers for the Golden Girl title was intense. When Meghan was selected, she was one of only four freshmen ever chosen Golden Girl. She was the featured star during every home football game, many of the home basketball games, and a few away games. Although Meghan relished having her dream come true, she eventually transferred to Emerson College to get her degree in broadcast journalism.

When she was on the pageant circuit, Meghan was required to showcase a talent, model an evening gown, and answer an onstage question. She remembers one question: "If you could invent something, what would it be?" Meghan's answer was practical: "I want something to clean my room."

This "cleanliness" theme continued following her graduation from Emerson College. Meghan was selected as a brand ambassador for Tidy Cats, a division of Ralston Purina, and their 2011 "No More PU Campaign." Meghan traveled about, doing good deeds on behalf of the company, including handing out free cupcakes to constructing a community garden from an overgrown, rat-infested city yard.

Meghan currently lives in Los Angeles, pursuing her dream of being a brand ambassador or television host. She has worked as a NASCAR hostess on Fox Sports, and at ABC, working with *America's Funniest Home Videos*. She also gives tours at Universal Studios. (Courtesy of Meghan Lamontagne.)

Gail Scott-Key

Gail Scott-Key grew up watching her father fight against the big company that was responsible for polluting their neighborhood. She learned that anything was possible; it just took determination and faith. She wanted a career in media relations, and she has since held several position in the field, both on-camera and off.

Scott-Key graduated from Pelham High School and went on to Northern Essex Community College. For three years, she worked with My-TV, producing unique stories for the My Health segment and setting up celebrities for interviews. Hosting "Careers in New England," she highlights healthcare facilities around the area and talks to healthcare professionals.

Each week, Scott-Key is on Pararocktv.com. As the host and producer of *Entertainment Now!*, she interviews guests ranging from writers, actors, musicians, and more. In 2013, she even had a part in a movie *Angels Around Me*, with Derrek Hammond.

With Gilbert Media Productions, she also hosts and co-produces *Cape Cod Winter Getaways and Lifestyles*. Scott-Key gets to visit restaurants, museums, hotels and resorts, showcasing the best. The show airs on the ION Network and ABC in Rhode Island. She co-hosts *Hollywood New England* with Miken Entertainment, highlighting people in and around New England that have ties in the media and film industry.

A collector of interesting shoes (preferably high heels), she enjoys spending time with her Poppy, her husband, Dan, and her nieces and nephews. Always with a smile, she frequently acknowledges her many blessings. (Both, courtesy of Gail Scott-Key.)

Houdini the Cow

Cows tend to wander in Pelham. In a former farming town, it is to be expected. The Zolkas family cows were especially known to get into everyone's yard or be in the middle of the road.

Leonard Russell, whose family owned a large farm off Bridge Street, found the cows eating an entire crop of his cabbage. The Zolkas family readily reimbursed Russell for the lost produce. Diane Brunelle would look out the window to see the cows drinking from her swimming pool. The animals would be retrieved. And Eleanor Burton recalls trying to get to church, but having to wait as the heifers crossed the road.

But none of the cows would become so famous as Houdini, the escaping bovine who made national news. In June 2010, the 800-pound Houdini was settling into her new home at the 30-acre Hirsch Farm on Mammoth Road. Spooked, she escaped her enclosure and went for a run through the woods and across Mammoth Road. About a dozen people were on site, trying to help corral the wayward cow away from traffic.

Some neighbors called the police. They arrived with tasers, which had been used to control animals previously. Houdini's owner, Wendy Bordeleau, begged the police not to use the taser, as it would scare the cow. "It's only going to make it worse," she warned.

As Houdini was being led back to her pen, the sergeant zapped her to keep her in check. He claimed that the cow had broken through a wooden fence next to him and he needed to control the animal. Because of her size, the shock was merely an annoyance. Eventually, Houdini made it home safely. The family added new fences to prevent future escapes.

Houdini might have been contained, but the story was out and made national news. The matter caused a lot of controversy, with one publication calling it an "udder disgrace." (Courtesy of Linda Doherty.)

Richard M. Linnehan

Many may not know that an astronaut in NASA's space program came from Pelham. During his career, Dr. Richard Linnehan has had four space flights, with over 59 days in space and six spacewalks.

Born in Lowell, Massachusetts, Dr. Linnehan was raised in Pelham by his grandparents. He attended school in town and was a member of Pelham High School's first graduating class in 1975. He went on to the University of New Hampshire, where he received a bachelor of science degree in animal sciences with a minor in microbiology. He also received a doctorate of veterinary medicine from Ohio State University College of Veterinary Medicine in 1985.

Selected by NASA in March 1992, Dr. Linnehan completed one year of Astronaut Candidate training, qualifying him for space shuttle flight assignments as a mission specialist. His first flight as a mission specialist was in 1996 on STS-78, the Life Sciences and Microgravity Spacelab (LMS) mission. In 1998, he served as the payload commander on the STS-90 Neurolab mission. In 2002, he was a member of the four-man EVA crew on STS-109.

In 2008, Dr. Linnehan asked Pelham to create a memento from the children of Pelham that he could take with him on his next space mission. He would be part of the crew for the shuttle *Endeavour* STS-123 mission to bring equipment to the International Space Station.

For Debra Laffond, the children's librarian at the Pelham Public Library, the challenge was two-fold. First was coming up with a plan that would involve as many children as possible, and second, figuring out what would be small enough to be taken aboard the shuttle.

In February 2008, children and families gathered at the library for a group photograph to be made into a key chain. Debbie also put together a special scrapbook of artwork, cards, and drawings.

When *Endeavor* lifted off on March 11, 2008, Linnehan had his hometown keepsake. (Courtesy of Pelham Public Library.)

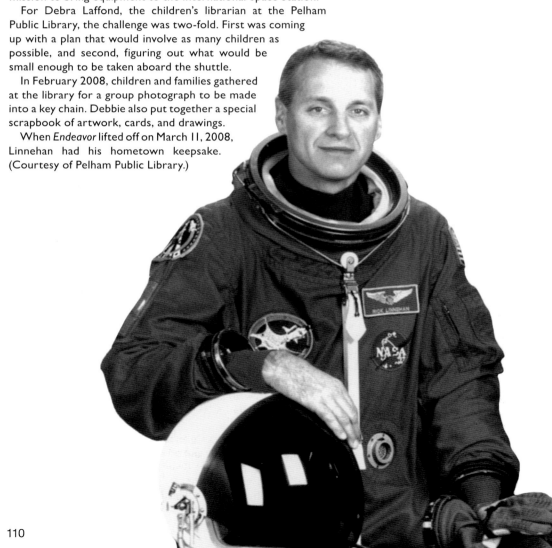

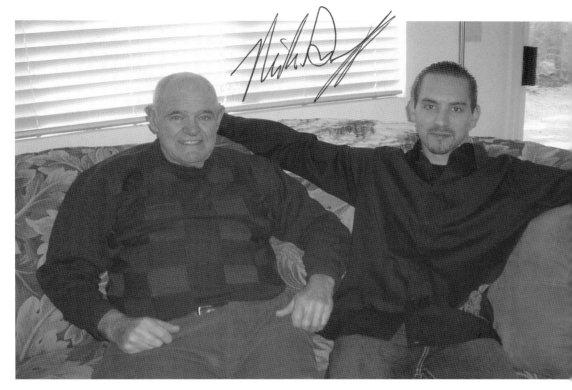

Nicholas Groff

A 1999 graduate of Pelham High School, Nick Groff is now seen regularly on the Travel Channel as co-investigator on *Ghost Adventures*. As an executive producer of the show, Groff is frequently behind the camera as he, Aaron Goodwin, and Zak Bagans visit haunted locations in an effort to document evidence of paranormal activity.

Groff is close with his grandfather (above left) and possesses his grandfather's love of sports. He attended college in Michigan on a sports scholarship and later moved to Las Vegas to study film at the University of Nevada. There, he met Aaron Goodwin, who would later become his co-investigator. Groff began his own video company, specializing in wedding videos.

Groff had a connection with the Travel Channel before *Ghost Adventures*. He was the executive producer of *Vegas Stripped*, a behind the scenes look at the operations of the South Point Hotel, Casino & Spa in Las Vegas. Groff became friends with Zak Bagans during Groff's wedding in Vegas, and the two started their paranormal investigations.

He is no stranger to ghosts. Groff fell out of a tree at age eight and had what he described as a near-death experience. Two years later, while home alone, he says he saw a ghostly black figure. He still wonders whether his fall from the tree made him more open to the spirit world.

During his paranormal investigations over the past several years, Groff has had all kinds of life-changing experiences. During an investigation of a brewery in Savannah, Georgia, he claims to have been possessed by an entity. Another encounter with a female spirit at a closed hospital in East Los Angeles gave him more insight into life after death.

In 2012, Groff launched his own clothing line, the Phantom Collection, and recorded an album, *The Other Side*. A second album was released at the end of the year and titled *Spiritual War: Good vs. Evil*. He has also published a book called *Chasing Spirits: The Building of the Ghost Adventures Crew*.

Groff lives locally now, with his wife and high school sweetheart, Veronique, and their daughter, Annabelle. In June 2013, he opened his own health club, Drive Health & Fitness, and has plans for expansion. (Courtesy of David Groff.)

Barbara Walsh

In 1988, Massachusetts governor Michael Dukakis ran for president against George H.W. Bush. Little did writer Barbara Walsh know that her work as a reporter for the *Lawrence Eagle-Tribune* would have such an impact on the campaign and the criminal justice system in general.

Shy as a child, Walsh preferred writing as her main method of communication. She studied photography and journalism at the University of New Hampshire. But deadlines were her biggest challenge, and she failed her writing class after turning in her final paper late. Regrouping, she traveled to Ireland for a year, taking a photography job at a weekly newspaper in Galway.

She returned to Pelham, writing for the local weekly paper, *Stateline X-Press*. During the next 25 years, Walsh worked as a reporter up and down the East Coast. She was assigned to write about the bleaker side of life—drug shootings in Florida, mentally ill children with no resources in Maine, domestic violence, and teen suicide.

But it was her job at the *Lawrence Eagle-Tribune* that she remembers most. "The Willie Horton story taught me that journalists have tremendous power and responsibility to inform, to tell stories that need to be told," says Walsh.

As part of a criminal rehabilitation program, Governor Dukakis supported weekend furloughs that included first-degree murderers. In 1986, while on furlough, convicted killer Willie Horton walked out of Walpole maximum-security prison and did not return. In 1987, Horton was convicted for the brutal assault and rape he committed while he was loose in Maryland. During the presidential campaign, the issue became front and center, as candidates attacked Dukakis for his liberal stance on crime.

From the start, Barbara Walsh was reporting on the story. She tirelessly interviewed prisoners and administrators from all over the country, bringing attention to the system that allowed a killer to walk out of prison. Her writing would eventually win the paper a Pulitzer Prize and lead to big changes in the criminal justice system.

Since then, Walsh has raised her children and published two books, *Sammy in the Sky* and *August Gale: A Father and Daughter's Journey into the Storm*. *August Gale* chronicles the true story of the deadly 1935 Newfoundland Hurricane that took the lives of several of her ancestors. Intertwined with the story of the physical storm is an adventure into forgiveness and understanding, as her dad begins to understand the man who abandoned him as a boy.

Walsh now lives in Maine and tries not to think about deadlines. (Courtesy of Barbara Walsh.)

CHAPTER TEN

Patchwork Quilt

Local news television shows love to do stories about ordinary people that have unusual lives or novel interests. Pelham is full of residents whose lives defy being placed in any established category. Their activities or skills are more one-of-a-kind and demand to stand on their own.

These people have contributed in ways that mark who we are as a town, a collection of the many unique pieces that make Pelham a great community.

Diane Brunelle

What are the odds having two children born on the same date, one year apart?

Diane Brunelle did one step better. Her first three boys were born on the same date, one year apart. Mike was born on January 21, 1967; Thomas on January 21, 1968; and Gary was born on the same date in 1969. Even more amazing, Mike and Thomas were both born at 1:21, though Mike chose the wee hours of morning while Thomas waited for afternoon.

A year later, her fourth son Billy got his own birthday, February 29, 1970, a leap-year baby.

Brunelle was 19 when she moved to Pelham, and has volunteered in the community for over 50 years, as a teacher's aid, CCD teacher, and with the scouts. She might hold a world record, but she is certainly one in a million. Pictured above from left to right are Michael, Thomas, Diane, and Gary. Pictured below from left to right are Thomas, Mike, and Gary. (Both, courtesy of Diane Brunelle.)

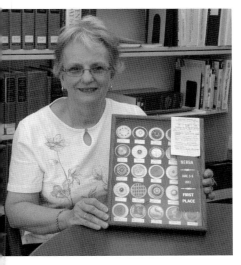

Leslie Kennedy

Starting with a collection begun by her husband's great-grandmother and grandmother, Pelham resident Leslie Kennedy has revived the art of button collecting.

She can identify the composition of each item, its age, and its history. With buttons from the 1700–1800s, the award-winning collection includes handcrafted items made with all kinds of materials, including elephant hair, pearl, various metals, bone, ivory, and shells. It is impeccably organized and categorized.

Button collecting began as a way for women to gather and socialize. Keeping their buttons in a "button bag," women would discuss and perhaps trade them. Kennedy has her husband's grandmother's button bag, with a few of her buttons still inside.

Over time, the women started to realize the diversity of their collections. In the 1930s, local and state clubs gave rise to the National Button Society. Kennedy belongs to many state and international groups.

IN SEARCH OF ALASKA'S LOST GOLD MINE

Florine Hirsch

A true story of prospecting adventures and bear encounters in the Alaska wilderness.

Florine and Robert Hirsch

Many New Englanders retire to someplace warm, where the living is easy; but not Florine and Robert Hirsch—they chose Alaska. And retirement has not meant slowing down.

Married over 50 years now, Pelham-natives Florine and Bob were longtime sweethearts. They raised five children while working a small family lumberyard and farm along Mammoth Road. Once their children were grown, it was time for their own adventure.

In 1984, Bob and Florine moved to Alaska. They began in an old log cabin with no modern conveniences. Florine wrote a weekly series for the local newspaper to chronicle their experiences. The articles led to a television series called *Alaska Adventures* and *On the Road Again with the Hirsch's*.

Florine published her first book, *In Search of Alaska's Lost Gold Mine*, in 1999. She followed it in 2007 with *Why, Why Alaska*. (Courtesy of the Hirsch family.)

Annis Albert "Duke" Vautier

The American Revolution was fought on the premise of "no taxation without representation." In Pelham, Duke Vautier was the champion of this cause.

Born in 1918 in Manchester, New Hampshire, the lifetime Eagle Scout worked for a Boston, Massachusetts, engineering office as a designer. In 1955, Massachusetts enacted an income tax law requiring nonresidents to pay taxes on income earned in the state. This affected many who lived in New Hampshire and Rhode Island who commuted to Boston.

The Committee to Oppose Non-Resident State Income Tax formed. Vautier and friend Paul Keenan of Hudson were both willing to be arrested to test the law. However, as Keenan's wife was expecting, it was decided that Vautier would be the one to go to jail.

Duke Vautier refused to pay the tax in on his income for 1956. In April 1959, he was arrested at his place of work for nonpayment of the tax, which totaled $140.80.

Vautier waived his right to bail, saying he preferred to be a test case challenging the law. Although 23 other states had similar laws, this was the first time any had ever been contested. His incarceration brought 150 irate residents from New Hampshire and Rhode Island to Boston where they picketed outside the jail.

The protestors carried placards berating the tax with slogans as "millions for defense but no one cent for tribute." But the group was orderly, and indeed, set the example for the Civil Rights protests to come. "We were very proud of him," said wife Charlotte (Moore). "We had groups contacting us, asking how we had pulled together such a large group to protest."

Back in New Hampshire, the legislature quickly passed a bill to petition Congress to draft an amendment to the federal constitution to prohibit taxation of nonresidents. Signed by the governor and sent to Congress, it marked the first time the state had ever initiated a change to the Constitution.

After about a week, Vautier's attorney paid $300 bail and a $500 bond to cover the tax liability. The case moved through the Massachusetts courts, and in 1960 Vautier was ordered to pay the tax. Taxes remained a concern, and Vautier became an active member of the Tax Relief and the Pelham Taxpayers Association. (Courtesy of Charlotte Moore.)

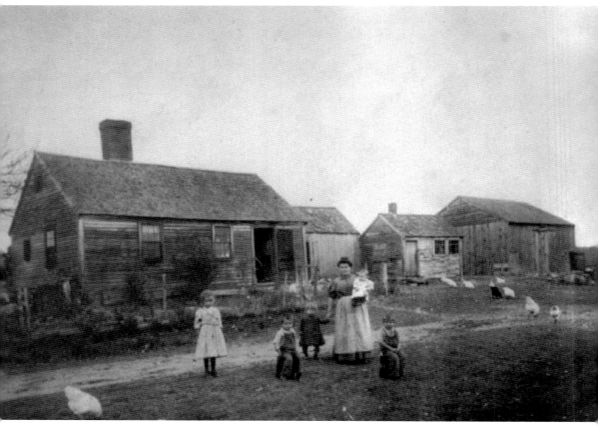

Victoria Bussiere Greenwood and Peter Greenwood

Around the turn of the century, large families were common, though not all of the children were fortunate enough to live. Victoria and Peter had a record 17 children survive. Many of these children remained in Pelham, including the parents and grandparents of Florine Hirsch and Jim Greenwood.

The family lived in a home near Simpson Mill and Hobbs Road. When the house burned down, they relocated to the Edwards House, located on Bridge Street on the corner of Balcom Road.

Peter worked as security for the trolley line. In fact, the trolley tracks passed in front of the house. In 1901, the corner became known as Greenwood Crossing. The track continued across Bridge Street and over to Little Island Pond. Victoria is pictured here with some of her 17 children. (Courtesy of Jim Greenwood.)

Albert Hirsch and Kali Hirsch

Born in Pelham in 1905, Albert Hirsch served in the Army with the 57th Squadron, also known as the Army Signal Corps. He loved to fly and was a flight instructor and part of H&H Airways, which licensed seaplane operations on Cobbetts Pond in Windham in 1947. He was also airport manager at Boire Field in Nashua.

Hirsch flew with John and Charles Steck on search and rescue missions. In 1937, he and Charles located the body of a 64-year-old man who had disappeared from his home in Hudson, New Hampshire.

In 1946, Hirsch and brother Carl formed Hirsch Brothers Construction Company. Officially incorporated in 1947, they completed projects throughout the state. They had equipment to perform major earthmoving tasks, road, street, and utility excavations, completing site work for many schools and industrial buildings.

In July 1951, Albert was flying with Carl to visit a work site in northern New Hampshire. The converted Army training plane crashed into Blye Mountain. Carl suffered severe head injuries, and within a week, passed away. However, Albert was able to walk away from the wreckage.

After the accident, Hirsch retired from construction. His daughter and son-in-law, Josephine and Paul Fletcher, took over the business. Albert opened a fix-it shop on Nashua Road, which he ran for many years.

Hirsch was a charter member of Pelham Fish & Game Club, served as Pelham's building inspector, road agent, and was one of many volunteer firemen in town. In fact, he helped to build Pelham's first fire truck from a Ford Model T.

At the 250th Anniversary Celebration in 1996, Albert Hirsch was recognized as the oldest living descendent of Pelham's founding family. At the time, Kali Hirsch was the youngest. She and her great-great-uncle Albert were part of the Anniversary Parade, riding in an antique car. (Courtesy of the Hirsch family.)

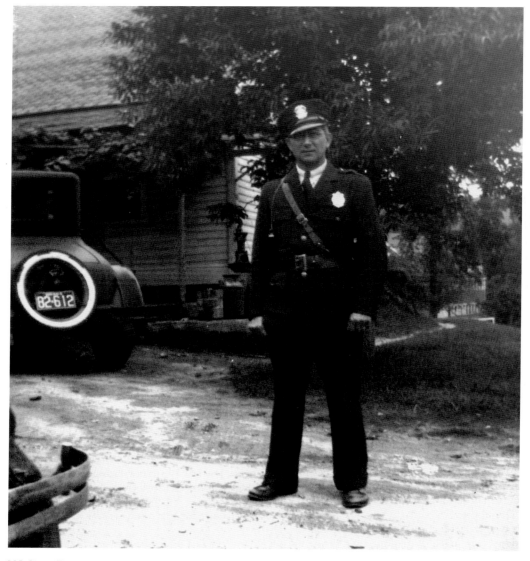

Walter Burton

Walter Burton was born in Pelham on March 18, 1895, the son of Fred A. Burton and Harriet Spalding. After attending school in Pelham, he worked for Gregg & Son in Nashua, and later worked for Merrimack Optical in Pelham. Walter was also a "special," an on-call police officer.

In 1917, he married Mabel Mortlock, and they raised four children: Donald, Robert, Velma (Houle) and Mary (Robinson).

Walter also served Pelham as a selectman, and he and his wife were involved in the Pelham Grange, Hill Rock Pomona, and state and national Granges. Burton served on the Pelham School Board for many years. In fact, Burton made the motion at a town meeting to name the expanded elementary school after his friend and neighbor, Ernest Sherburne, to honor his dedication to the schools.

He and his son Donald were active in scouting. Walter and Don were among the first of Pelham's Eagle Scouts. A Boy Scout leader for many years, Walter attended the 1937 National Jamboree; Don went in 1957. (Courtesy of Jane Provencal.)

 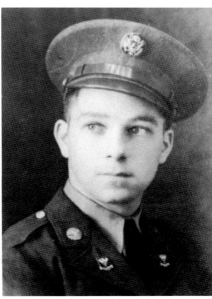

Donald E. Burton and Donald H. Burton

Walter's son Donald E. Burton was described as one of the most unassuming and unpretentious people. He never offered a comment until asked. Don was very involved in the town, serving on the budget committee. However, he refused to pay the filing fees or put up campaign signs. If the people wanted him, they would elect him, he said.

Don played baseball in high school. There he met Eleanor Herbert, who would watch his games. They became a couple. Following high school, Don joined the Army Air Corps, traveling to Biloxi, Mississippi, for training before reporting to Eglin Air Force Base in Florida. Eleanor, who had been in nursing training at the time, followed the steps of many others. She flew to Florida to marry her boyfriend before he was sent overseas. But Don remained in the United States, and in 1943 Don and Eleanor had a son, Donald Herbert Burton. Later, twin girls, Jane and Joyce, arrived.

Self-employed as a carpenter, Don also held a teaching degree. For 30 years, he taught in Leominster at the high school's trade school. Every year, with the help of Harold Mooney, the class would build a house in Leominster, Massachusetts.

Don also coached little league. There was not much opportunity for girls to play sports, so he allowed his twin daughters to practice with the team.

Don's son loved planes. For over 40 years, Don H. worked as a jet mechanic for US Airways. He served with the US Army National Guard and was a reserve during the Vietnam War. Sadly, in 2004, Don H. passed far too soon at age 61. (Both, courtesy of Eleanor Burton.)

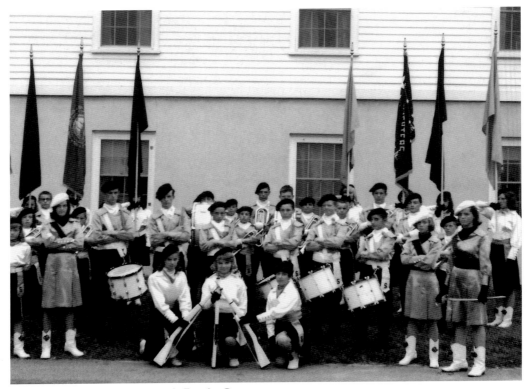

Starlighters Junior Drum & Bugle Corps

Drums, bugles, color guard and baton twirlers: approximately 70 children made up the Pelham Junior Drum & Bugle Corps. The group formed in October 1963 and was "a dream come true" for manager and director Joseph C. Minnon. A Navy drummer, Minnon had marched in Pres. Franklin D. Roosevelt's funeral cortege.

Because of Minnon's enthusiasm and determination, private citizens and civic organizations were happy to give generous donations. He raised over $1,500. Minnon served as drum instructor, Norman Duchesne was in charge of the color guard, and Delia Floyd led the baton twirling instruction. Children as young as 10 and as old as 21 were in the group. Dot Hardy and several other mothers created the handmade uniforms worn by the corps members.

The Starlighters made its first public appearance in the 1964 Memorial Day Parade in Pelham. Over the summer, they took part in July 4 celebrations, church events, and fairs in towns all over New Hampshire. They won the first of many trophies in the 1964 Pelham Old Home Day Parade.

As the second season began, a Starlighters Boosters Association was formed to support the group morally and financially. Spring 1965 brought more awards in field contests and the American Legion Convention Parade Contest in Keene, New Hampshire. The Starlighters were champions four times in the State Class B competition in 1968.

The victories came with financial prizes, which allowed the corps to purchase new uniforms. They featured sparkling blue blouses and black pants, silver ornamental caps and white shoes and gloves.

In 1969, the Starlighters accepted invitations for more ambitious competitions, including marching and maneuvering in the Class B section of the All-American Circuit. They added more awards to their collection, taking top honors for Color Guards in Newburyport, Massachusetts.

Unfortunately, several changes in leadership led the group to eventually disband. The uniforms and equipment were sold, and the funds used to create a Starlighters Scholarship at Pelham High School. (Courtesy of Eleanor Burton.)

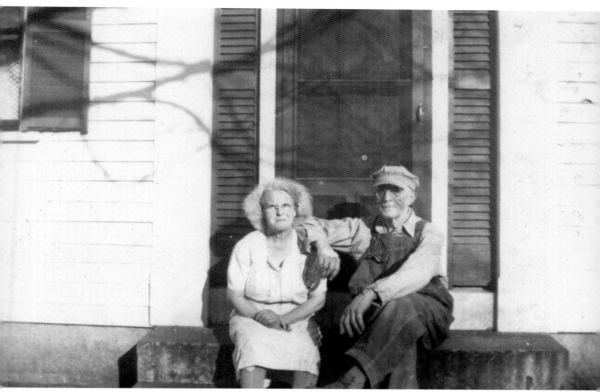

Ludwig Adolph Oscar "LAO" Hirsch

The Hirsch family is well known throughout Pelham. Their story began when Ludwig Adolph Hirsch arrived in Pelham before the turn of the 20th century and started a family that would spread throughout the town.

LAO, as he was known, was born in Witten, Germany in 1875, to August Hirsch and Caroline Gruber. As a young man, he arrived in the United States and worked in Lowell, Massachusetts, delivering ice. Looking for a change, he asked a farmer if he needed help. The pay was low, but they offered him room and board.

He ended up on what is now the Steck Farm at the top of Jeremy Hill. The poultry farm was previously Spaulding Tavern, a boardinghouse. Nellie Currier was also working there. They met and were married in 1900 in Lowell. Later, they had three children—Harriet (Mansfield), Carl, and Albert.

LAO had also worked as a conductor on the trolley in Pelham. Luckily, he was not working that fateful September morning in 1902 when, on a blind curve north of Pelham Center, two trolley cars collided head on. Crews responded quickly, helping riders emerge from the wreckage. In the end, however, six people lost their lives. It was the worst accident of its time.

In 1945, he and Nellie celebrated their 45th wedding anniversary. (Courtesy of the Hirsch family.)

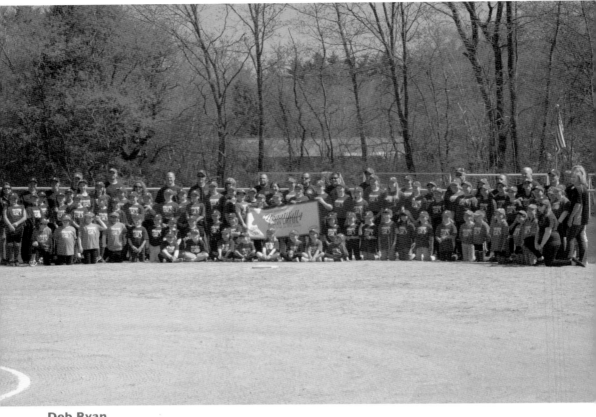

Deb Ryan

With Deb Ryan serving as president, Pelham Softball launched the Beautifully Powerful campaign on Opening Day, May 2011. The slogan was coined by Louisville Slugger to define the millions of girls, teens, and women who play softball. The women are "beautifully powerful" by staying true to themselves, finding the beauty and power within themselves.

Over the past few years, Pelham Softball has found their own power. Through various fundraisers, sponsorships, contributions, and their own hard work, the organization has improved the fields, fixed up their dugouts, and created a fall team as well as various clinics throughout the year.

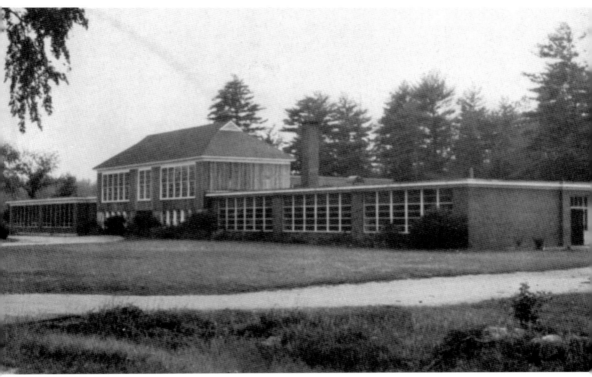

Ernest G. Sherburne
Originally a junior high school in the 1920s, Sherburne School, named for Ernest G. Sherburne, has had many additions and renovations over the years, and is now Pelham Town Hall.

Even now, the building continues to undergo renovations, as the town continues to grow and needs change. The building now houses all town offices, as well as the Pelham Police Department. Several years ago, the Sherburne Hall Committee raised the funds to restore the main hall to accommodate public meetings and events. Space still remains for future use. (Courtesy of First Congregational Church.)

WORKS CONSULTED

Ancestry.com

Eagle Tribune

Hayes-Genoter History & Genealogy Library

Lowell Sun

Nashua Telegraph

Pelham Annual Town Reports

Pelham Historical Society

Pelham Public Library

INDEX

AN IMPRINT OF ARCADIA PUBLISHING

Find more books like this at
www.legendarylocals.com

Discover more local and regional history books at
www.arcadiapublishing.com

Consistent with our mission to preserve history on a local level, this book was printed in South Carolina on American-made paper and manufactured entirely in the United States. Products carrying the accredited Forest Stewardship Council (FSC) label are printed on 100 percent FSC-certified paper.

MADE IN THE USA